Painted Buddhas
of Xinjiang

© Éditions de la Martinière, 2002
Title of the original edition: Le Pinceau de Bouddha
Published by Éditions de la Martinière, Paris

English translation © 2002 The Trustees of The British Museum
Translated by Ian West in association with First Edition Translations Ltd, Cambridge (UK)

First published in the USA in 2002 by
Art Media Resources, Ltd.
1507 South Michigan Avenue
Chicago, IL 60605 USA
www.artmediaresources.com

ISBN 1-58886-027-2

A CIP record of this book is available from the Library of Congress

Printed in Italy

REZA

Painted Buddhas of Xinjiang

Hidden Treasures from the Silk Road

Jacques Giès
Laure Feugère
André Coutin

ART MEDIA RESOURCES

Contents

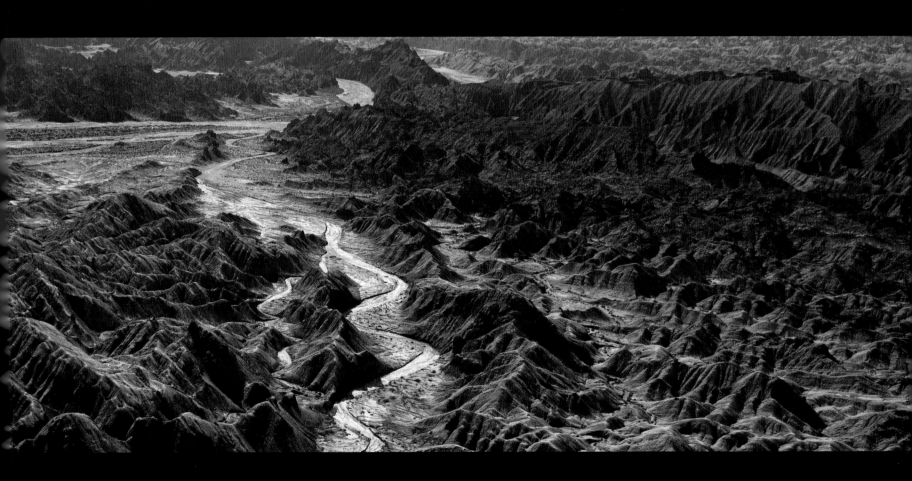

All the photographs in this book were taken in the caves at Kizil,

except those of the Chimney Cave and Cave 49, which are at Kumtura.

AND THERE WAS LIGHT IN THE CAVES OF XINJIANG

On the roof of the cave, wild geese wheel around the sun and a fabulous bird looms out of the shadows. On the walls, a gazelle and a blue elephant parade under the floodlights; swathed in luminous halos, men are suspended in the act of levitation. Princes, horsemen, ascetics, musicians – a whole tribe of human and animal figures – gravitate around the emblematic image of the Buddha. This Buddha of the Shadows rules over the subterranean world where Maoist China confined him to oblivion for half a century.

Perched on a precarious scaffolding, Reza, the only Western photographer authorized to shed light on this secret place, is well aware of the privilege. Though his journey back in time takes him only to the earliest centuries AD, he experiences the same emotion as a visitor whose torch suddenly reveals a rock-painting from prehistory. He is conscious of restoring to life a hidden splendour, the laborious work of the monks who painted these caves and to whom the Enlightened One had whispered: 'You are the brush of the Buddha …'.

A palette dominated by blue, green and red, contrasting tones of light and shade, a variety of styles, a wealth of motifs … . The camera captures scene after scene of the multiple incarnations of the Buddha, interpreted in the popular tradition and an integral part of the everyday lives of the Indo-European people whose roots lie in the Central Asian steppe lands. This region, Iranian and Turkish in its culture, was annexed in 1950 by China as the Province of Xinjiang.

The walls of the caves resemble a jigsaw puzzle with pieces missing. In entire areas, the support has been stripped away. The sandstone was lined with a base consisting of clay, straw and the hair of various animals. On top of this was a coating of stucco. Some of the damage suffered by the paintings is the work of Nature (erosion, crumbling of the fragile rock); elsewhere it betrays the

7

hand of Man: deliberate mutilation by iconoclasts, theft, samples removed by archaeologists. At least the fragments preserved in museums are safe from the ravages of the climate. Unlike the grand Tibetan monuments, the Xinjiang shrines escaped the Red Guards of the Cultural Revolution, safe underground in the darkness. Yet this very oblivion could have proved fatal, as for any works of art threatened with decay.

The First World War put an end to the exploration of the caves, which sank back into their mysterious sleep. They remained inaccessible after the installation of the Communist regime, when the region became isolated from the world. In 1950 an archaeologist from Beijing visited the new province and its sites. He petitioned the authorities in Urumqi, the regional capital, to protect the caves, and an official curator was appointed. The choice fell upon a Kuchean teacher, Muhammat Mussa. He was a Uygur (or Uighur). His people, of Turkish origin and Muslim by religion, knew little of Buddhist history – they believed the ruins were haunted by demons. Anxious to discover more about his site, Mussa began to study the history of the Northern Silk Road, and fell in love with the beauty of Kuchean art.

Situated to the west and east of Kucha, the painted caves are not natural, but carved out by man in the cliffs separating the Taklamakan Desert and the Muzat River. Kucha today is a small town, grey and dusty. As he left it, Reza found it hard to picture the once flourishing city-state, an obligatory halt on the Northern Silk Road, where caravans from the Mediterranean met those en route from China. Two statues of the Buddha, nearly 90 ft (27 m) high, flanked the entrance gates of the city. Its oasis was planted with fruit trees: pomegranates, pears and apricots. The beauty of its peacocks was legendary and in the steppes, where game abounded, men hunted gazelles. The peasants grew red maize, wheat, and even rice, while beneath the earth lurked rich veins of gold. The kingdom was a haven for the arts, welcoming learned pilgrims and providing patronage. And there was

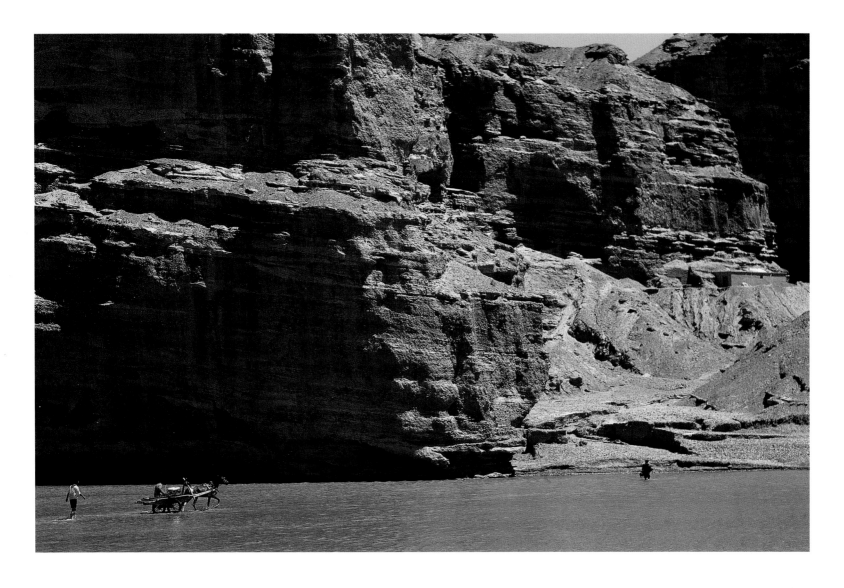

music: the melodies of Kucha were heard at the Imperial Court in China. Wealthy donors enabled the monks to decorate the sanctuaries of the new religion and so, from the dawn of our era, the light of the Buddha flooded their subterranean chambers.

At the end of the twentieth century, apart from the occasional archaeologist, no foreigner was allowed to enter the caves to take photographs. Reza, a press photographer, was only granted permission because he had lived for a long time in Xinjiang working for the *National Geographic Magazine*. His knowledge of the

Fording the Muzat River to get to the cliffs.

Uygur people and Turkoman culture enabled him to find the right intermediaries. The negotiations lasted for weeks; meanwhile, his visa was approaching its expiry date.

'I had to argue every inch of the way, taking care not to offend Chinese suscepti-bilities. "Such treasures", I pointed out, "deserve to be recognized as the heritage of mankind as a whole. If you let me photograph them, every other nation will realize how priceless they are."' Once agreement had been reached in principle, Reza was finally able to start choosing his sites. 'I had to pick 10 caves out of 363 from the ancient kingdom of Kucha, narrowing the choice down to the paintings with the best-preserved colours in the best-preserved caves.'

The predominant artistic influence on the northern route is the Gandhara style, which depicts the Buddha with the flowing locks and fine features of Greek *kouroi*. But in the Kucha region, we see an intercultural and transitional stage in the spread of Buddhist art eastwards towards Asia, just before the Chinese style proper takes over. Here, Iranian, Afghan and Indian influences come together in a dramatic confrontation. For this reason, Reza opted for the two most impressive sites in that area: Kizil and Kumtura.

Having secured his permit, however, he was still not at the end of his battle to reach the caves where the 'brush of the Buddha' had traced out its living legend. In the 1950s, the only means of travel was by horse, along small tracks. From Kucha, it took two days to reach Kizil or Kumtura. Today, trucks grind their way along a route that is frozen in winter, their wheels slithering perilously near the edges of the ravine. To reach the foot of the Kumtura cliffs, you have to cross the Muzat River. 'Fording the river, I was terrified for my equipment on the cart', recalls Reza. 'The horse suddenly reared up. Cameras, films, reflectors, mirrors, some 550 yds (500m) of electric cable … Was the lot about to go into the water? In a panic, I think I was speaking English, French, Turkish and even Persian. I don't know which of the latter two languages calmed the animal down, but we got across without disaster.'

Curator in front of a 'stupa' (central pillar). [Cave 171]

10

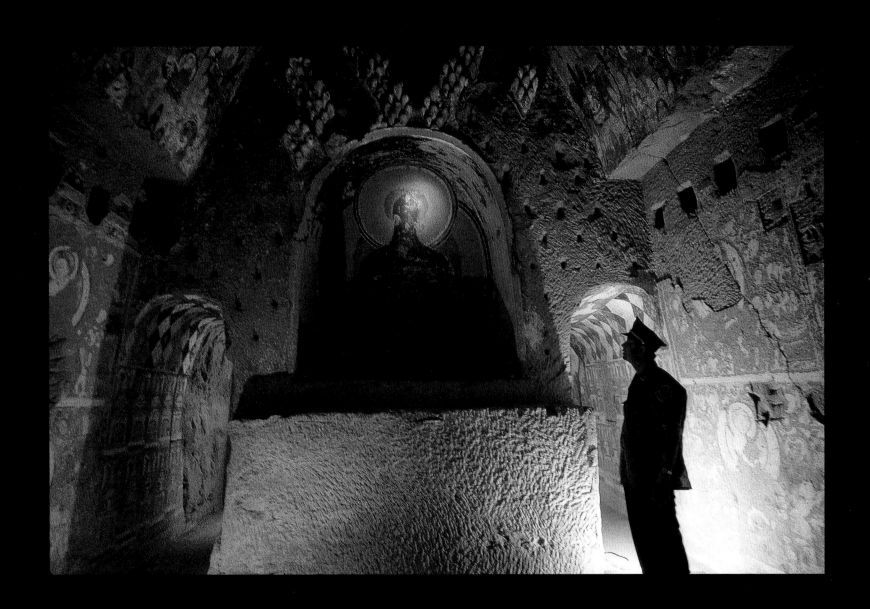

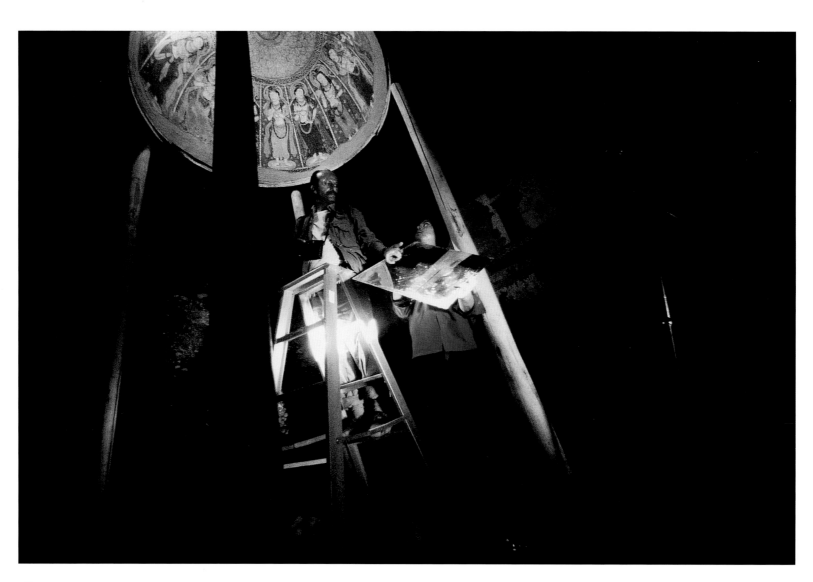

*Illuminating a
cave with a system
of mirrors to reflect
daylight from the
entrance to the
wall paintings.
[Chimney Cave]*

There remained the ascent of the escarpment, over 650 ft (200 m) high, to reach the entrance to the caves. At Kizil, west of Kucha, on the other side of the mountain, the climb is very strenuous in the burning desert wind, and one's feet are constantly slipping on the scree.

Once inside the caves, the only way for the photographer to light the paintings was using sunlight. Curators and volunteers formed a chain, each holding one of Reza's mirrors. 'I asked them to form a line, zigzag-fashion, from the cave mouth to the painted chambers. That way, the mirrors would reflect the daylight onto the walls we were filming.'

Thanks to these exceptional photos, we now have access to an illustrated 'bible' of Buddhism. The hidden treasures of Turkestan reproduced in this book are among the world's masterpieces. The artist-monks of Kucha, with their subtle brushwork, their inspiration and skill, have received their just reward: their rock-paintings are now classed as a World Heritage Site.

André COUTIN

R U S S I A

Kazakhstan

Mongolia

Uzbekistan

Urumqi

Turkmenistan
Kyrgyzstan
Turfan
Tajikistan
Kucha
XINJIANG
Kashgar
Afghanistan
Taklamakan Desert
Kunlun Shan

Pakistan

C H I N A

Japan

N. Korea

S. Korea

Nepal

Bhutan

Bangladesh

I n d i a

Burma

Laos

Thailand

Cambodia

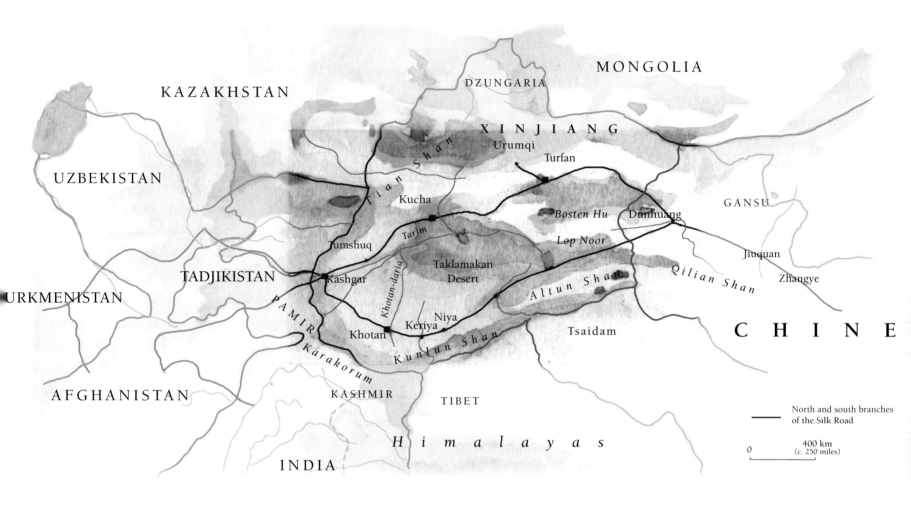

KAZAKHSTAN

MONGOLIA

DZUNGARIA

UZBEKISTAN

XINJIANG

Urumqi

Turfan

Tian Shan

Kucha

GANSU

Bosten Hu

Dunhuang

Tarim

Lop Noor

Tumshuq

Jiuquan

TADJIKISTAN

Kashgar

Taklamakan
Desert

Qilian Shan

Zhangye

Khotan-daria

Altun Shan

URKMENISTAN

PAMIR

CHINE

Niya

Keriya

Karakorum

Khotan

Kunlun Shan

Tsaidam

AFGHANISTAN

KASHMIR

TIBET

North and south branches
of the Silk Road

Himalayas

0 400 km
(c. 250 miles)

INDIA

Serindia (North Tarim) forms a major
archaeological entity in Central Asia, covering
the territory of the former Eastern Turkestan, now
the Chinese province of Xinjiang (capital
Urumqi). The overland Silk Road had various
branches. The two principal ones were the
northern and the southern routes, which became
the major axes along which Buddhism spread
from India to Central Asia and China. Kucha was
a favoured halt for caravans and pilgrims on the
northern route. This royal city-state was rich in
rock sanctuaries spread over four sites, of which
Kizil, Kizil-Qargha and Kumtura, on the Muzat
River, are the most significant from an
archaeological and art-historical point of view.

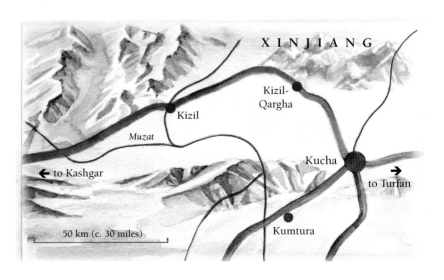

XINJIANG

Kizil-
Qargha

Kizil

Muzat

Kucha

← to Kashgar

to Turfan →

Kumtura

50 km (c. 30 miles)

The hidden treasures of Turkestan

The caves of Kizil and Kumtura, despite the attentions of robbers and the loss of sculpted objects, remain sanctuaries of cave art. One in particular, the Musicians' Cave, offers a revealing insight into the internal architecture of these underground chambers with their treasures secreted in darkness. An amalgam of Indian, Greek, Iranian, Afghan and Chinese styles, the wall-paintings are masterpieces of their type. The vitality of their brushwork and their vivid colours strike the Western visitor as astonishingly modern. These pilgrimage sites represent a crucial stage in the spread of Buddhism through Central Asia towards China, their strategic geographical position holding the key to the cultural influence of the mysterious kingdom of Kucha.

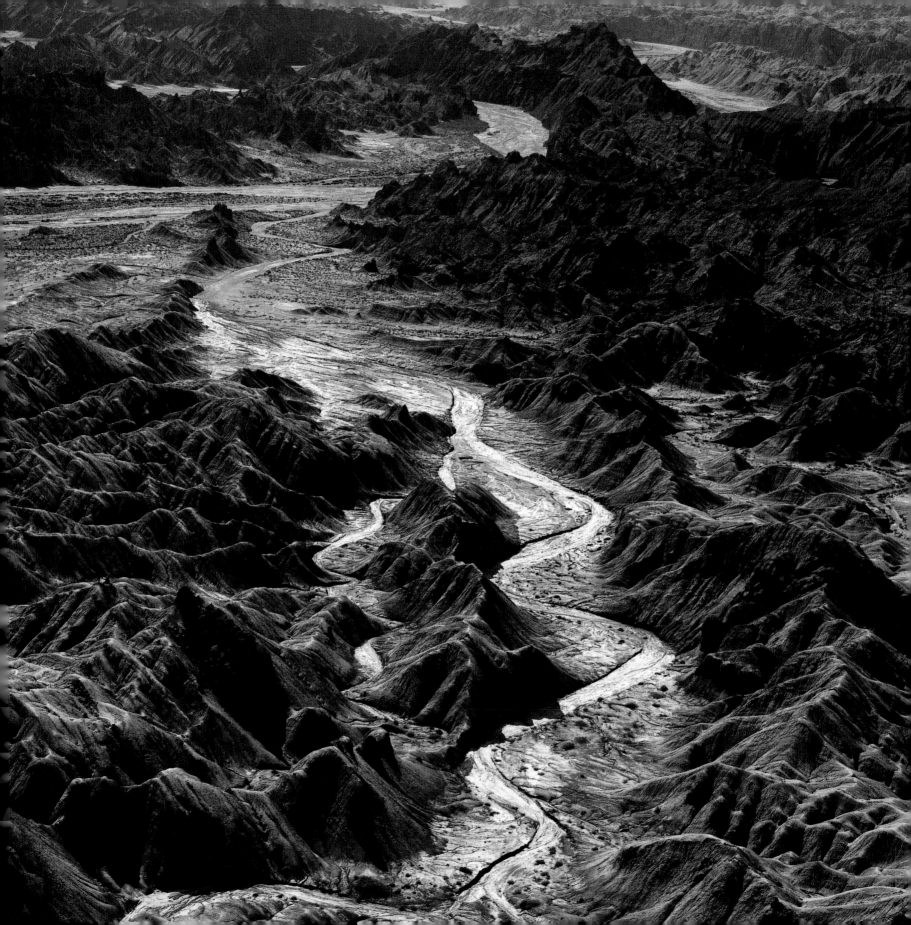

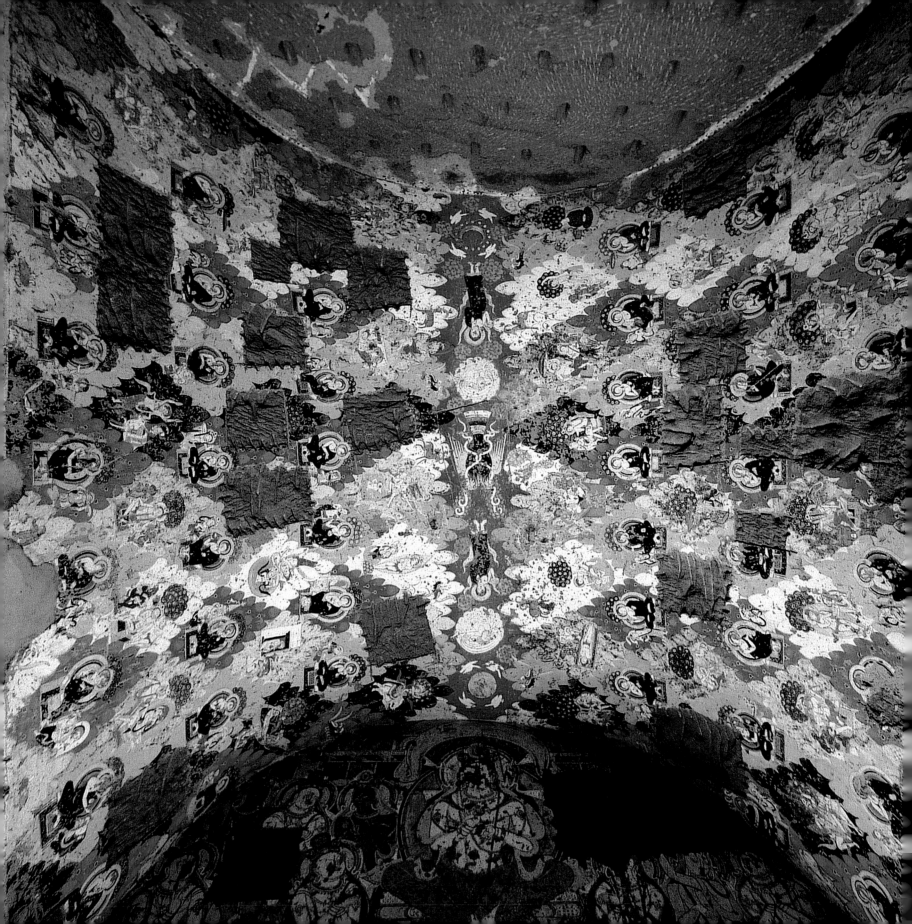

THE MUSICIANS' CAVE

To visualize the structure of the caves dug into the cliffs along the Muzat River, let us look at the shrine known as the Musicians' Cave, no. 38 in the present numbering system (see p. 167). This cave is typical in its internal architecture.

About 20 ft (6m) long and 13 ft (4m) wide, it has as a central feature (roughly halfway across the floor area) a *stupa* in the form of a pillar, in the middle of which has been hollowed out a niche for a cult statue. This would have shown the Buddha seated cross-legged; all that now remains is the halo and mandorla painted on the background. The niche is more than 3ft (1m) above the ground, and measures just over 4 ft (1.3 m) in height.

The ceiling of the cave consists of a barrel vault, divided by a central pillar. [Musicians' Cave]

To the left and right of the *stupa*, two barrel-vaulted passages lead to a depiction of Shakyamuni (the historical Buddha) in *parinirvana* (the posture of the Buddha, recumbent, in anticipation of total *nirvana*), surrounded by his monks, painted almost life-size on the background wall. Here it was possible to carry out the Buddhist ritual *par excellence*, known as *pradakshina*, which consists of meditation performed whilst circling a *stupa* in a clockwise direction. Here, the *stupa* is represented by the central pillar.

On entering the cave, the eye of the disciple would be drawn by the decoration on the barrel vault, stretching from the entrance (once preceded by a small vestibule) to the *stupa.* The vaulting is divided into two by an ornate frieze running vertically overhead. At the end nearest the entrance is the sun, surrounded by wild geese; next comes a standing Buddha with flames at his shoulders and a scene showing Mt Meru, mystical centre of the world, encompassed by serpents, the winds, and thunder. At the other end, we find a crescent moon within a circle of stars. On either side of this axis, there is a setting of highly stylized mountains painted as blue, green or white lozenges, from which emerge monkeys, bears, cats and birds,

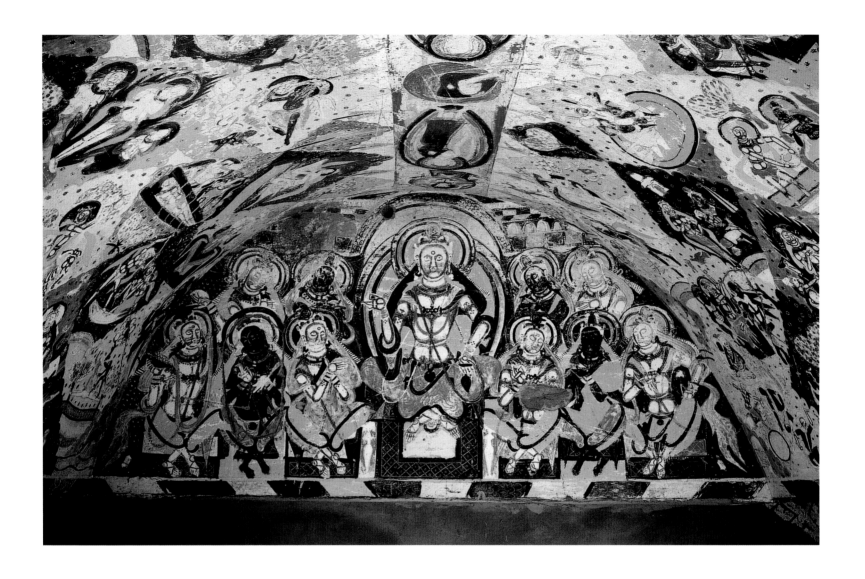

A lunette-shaped tympanum, above a cave entrance – here with a gathering of bodhisattvas. [Cave with the Bodhisattva Vault]

as well as monks, princes, merchants – and, more rarely, women. These are the characters of the *jatakas*, tales of the previous lives of the Buddha.

The so-called Musicians' Cave was named by Albert Grünwedel during his archaeological expedition of 1906. The title derives from the frieze running round the upper levels of the side walls, where they meet the vaulting. Here the artists have portrayed half-length figures of musicians playing instruments in use in Kucha, whose performers were celebrated at the Tang court for their skill and beauty.

It is said that the introduction of Kuchean culture to the Chinese court goes back to the expedition of General Chang Ch'ien in 138 BC. Later, in AD 382, Lu Kuang, having brought the lands to the west under the emperor's control, returned with his booty, which included actors, musicians and dancers from Kucha, whose musical tradition had been influenced by that of India. The instruments used were the five-stringed lute, the harp, mouth-organ, drums and cymbals. The orchestra was later enriched with the true Kuchean lute, which has four strings. Indian music was introduced to Kucha at the same time as Buddhism. Much evidence of its role is visible in the Kizil caves, where musicians are shown accompanying preaching scenes, or, as here, occupy niches just below the vaulting, where this celestial orchestra reminds one of the couples painted on the balconies of the Indian caves at Ajanta.

The side walls, now in a very dilapidated state, once showed the Buddha preaching to a crowd of attentive disciples and lay followers. Above the niche holding the cult statue, marks appearing in the cob cladding seem to indicate that the original decoration may have depicted a mountain – a stylized mountain, as on the vault, but here made out of dried earth. The relief would have produced a sort of *trompe-l'oeil* effect which would have been very impressive glimpsed through the half-light. The same device is found in several caves. The ceilings of the passages leading to the Buddha's death-scene echo subjects found elsewhere in the caves: the narrow vault, again in barrel form, is painted with highly stylized, lozenge-shaped trees of different colours continuing down on to the walls. Rising from the floor, rows of *stupas* adorned with long, floating banners attract the attention of the faithful as they circumambulate the chambers. Each *stupa* bears the image of the meditating Buddha, clothed in a brown robe. The whole of the background wall is taken up by the *parinirvana* scene. The head of Shakyamuni, who lies on his side, reposes on a voluminous pillow, in front of which we can make out the silhouette of a monk. Grief-stricken monks and princes bend over the body.

Kneeling at the Buddha's feet, slightly to the fore, is Kasyapa, an old monk who is clearly visible from the passage entrance.

At the end of his visit, the pilgrim would have lifted his eyes to the painted tympanum over the entrance, where he would glimpse the bodhisattva Maitreya amidst the divinities. On either side of the doorway a small niche has been excavated; it no longer contains any images, but no doubt the walls were once painted.

Laure FEUGÈRE

The central figure, seated among the bodhisattvas, is the Buddha Shakyamuni [Cave 49]

▶▶ Side walls showing preaching scenes and episodes from previous lives of the Buddha Shakyamuni. [Cave with the Bodhisattva Vault]

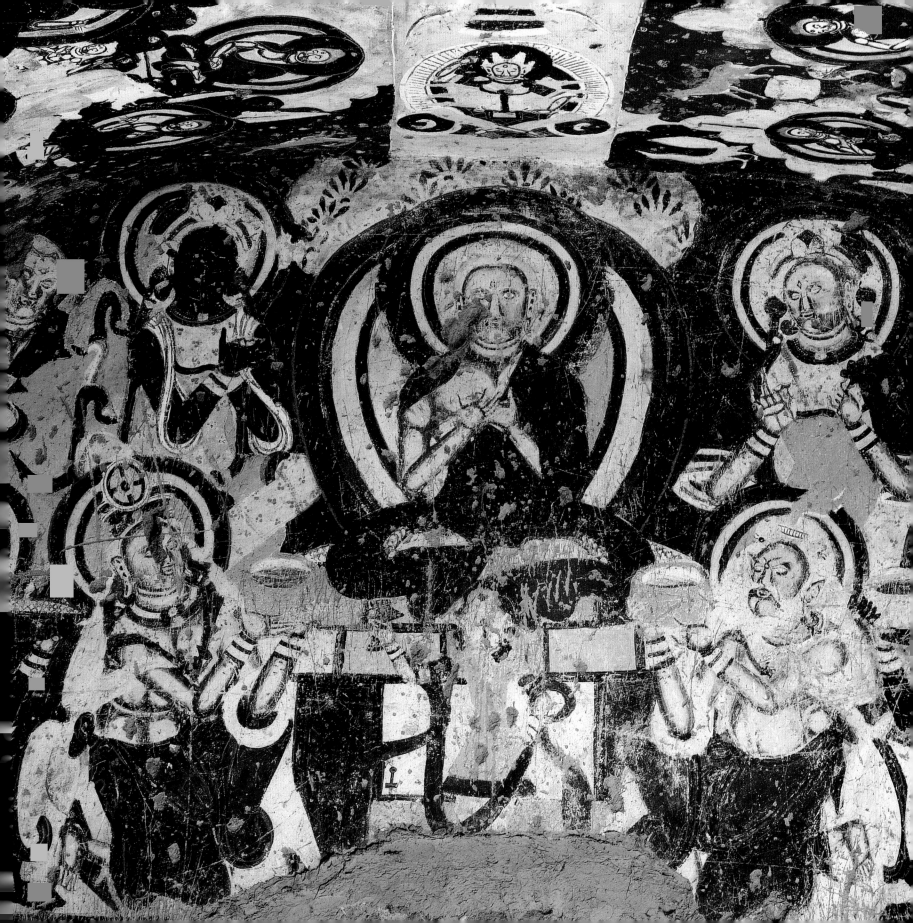

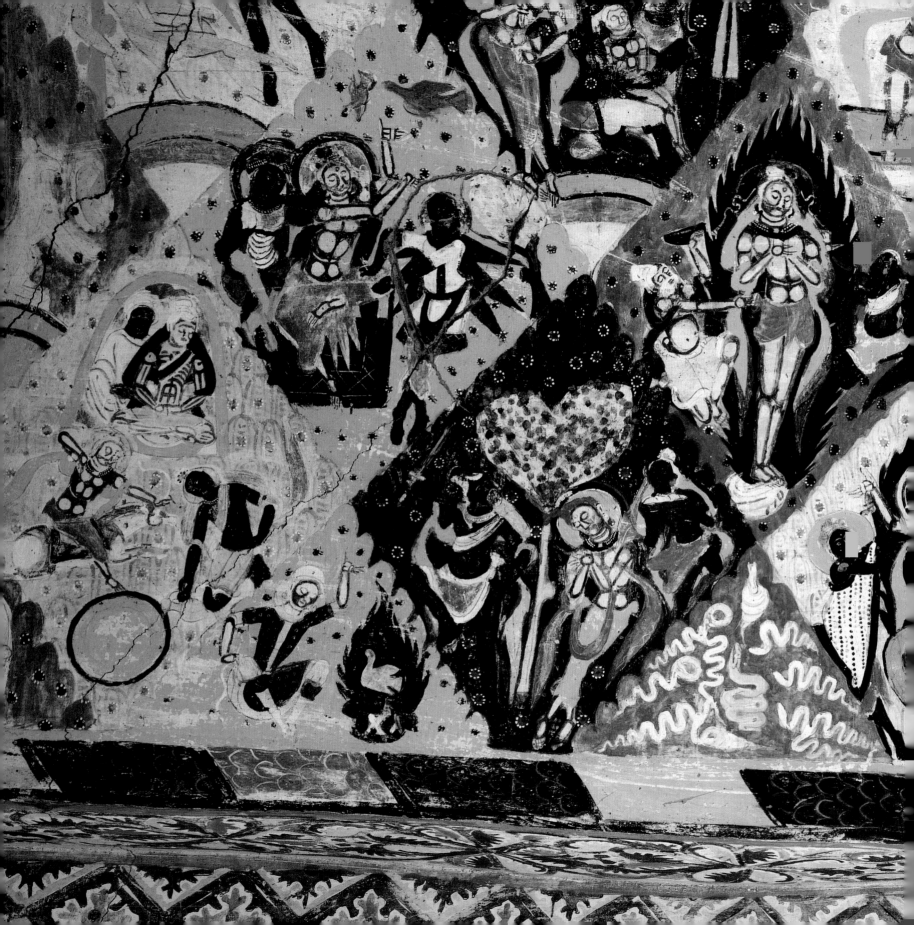

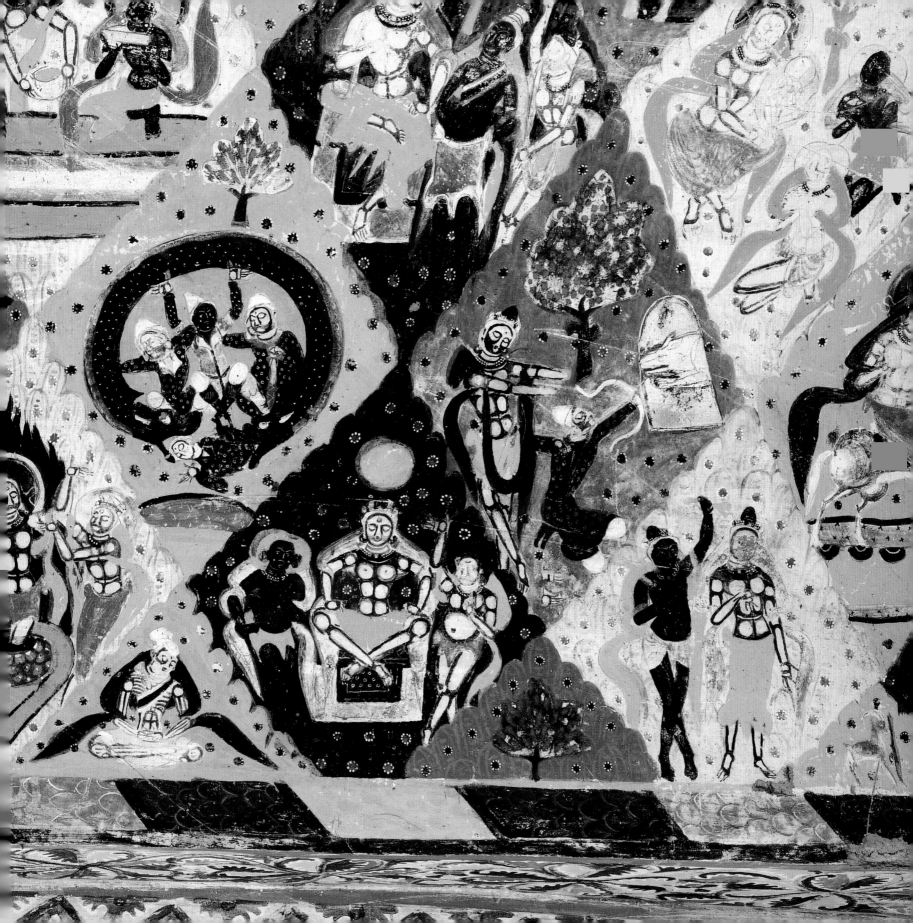

The internal architecture of the Kizil caves

Each painted cave is a microcosm. Architecture and decoration were designed to initiate the visitor into the world of the Buddha and allow him to make the ritual circuit of *pradakshina* (circumambulation). Immediately on entering, the monk or Silk Road pilgrim, without turning round, would raise his eyes to the vault overhead, which symbolized the cosmos and the zenith; he would then contemplate the image of the Buddha in the niche of the central pillar that formed the sanctuary's *stupa*. To reach the back of the chamber, he would take the left-hand branch of an ambulatory, viewing as he went murals of the Enlightened One's former lives and his teaching. He then emerged into the second part of the very narrow cave to discover, in the background, the Buddha recumbent in *parinirvana*. To return, he took the right-hand passage; having thus circled the *stupa*, he now faced the entrance, where his eyes would light on Maitreya seated with his disciples on the tympanum. Maitreya is known as the Buddha of the Future, or, more precisely, the bodhisattva destined to become a Buddha.

Dimensions in centimetres

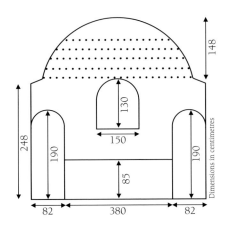

Plan of a typical cave. This example shows the Musicians' Cave, plotted in 1906 by Albert Grünwedel, one of the first archaeologists to excavate at Kucha. The measurements indicate the scale of the two chambers and the central pillar.

Dimensions in centimetres

▶ *In most instances, the interior of the cave was divided into two chambers by a central pillar. To circumambulate this, visitors followed two side passages.*
[Cave 49]

26

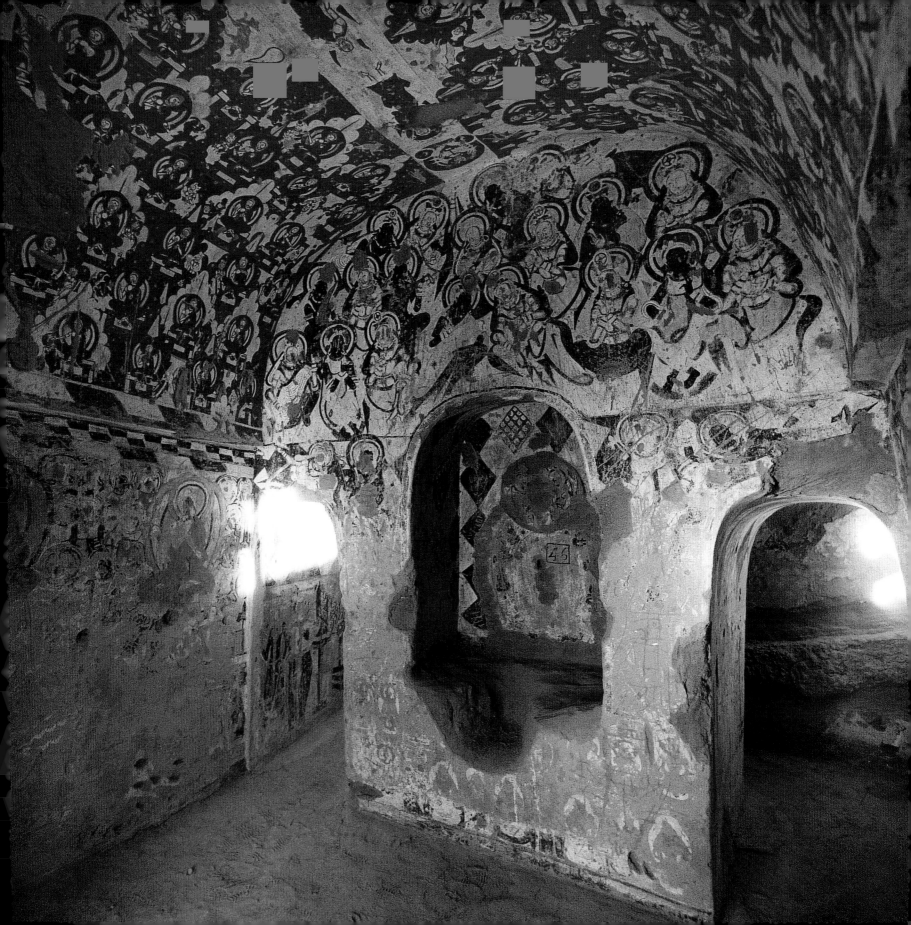

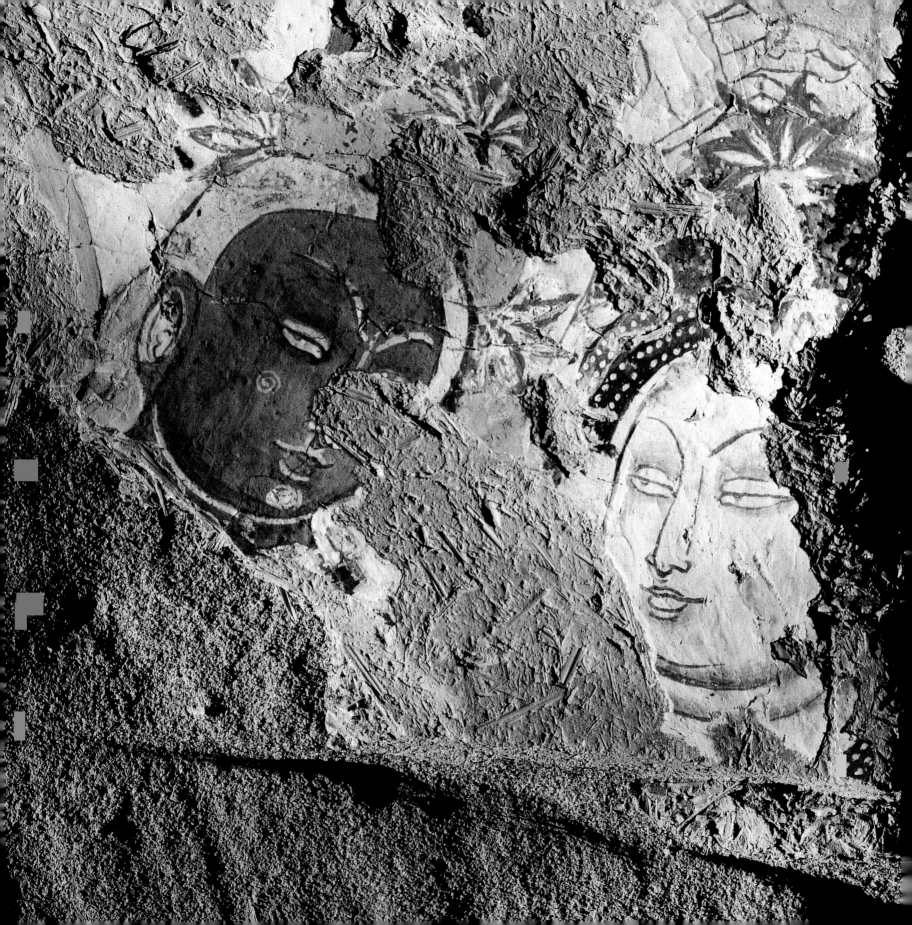

MASTERPIECES OF WALL PAINTING

Clay, straw and plaster

Apricot juice was used to bind the cob support. The sandstone wall, the clay base, with straws sticking out, and the final plaster layer are all clearly visible. This fragment shows the different stages in the preparation of the support. [Maya Cave III]

Despite the damage caused by time and Man, the caves at Kizil are among the most spectacular examples of rock painting not only in Asia but in the entire world. The collection exhibits both a remarkable unity and considerable diversity. What was a petty kingdom of the Tarim basin managed to absorb the finest artistic traditions of Gandhara, Sogdiana, India, and, even further afield, Iran, through the intermediary of travellers who passed on their ancestral heritage. Buddhist monks who practised Hinayana ('the Small Vehicle') were gradually converted to Mahayana ('the Great Vehicle'); not content with teaching Buddhist doctrine, they lavishly portrayed the universe of myth and legend and blended it with scenes from the lives of their contemporaries or from Nature, suffusing their realistic depictions with poetry. To Buddhists the world is but an illusion, yet, at Kizil, the monks achieved the paradox of turning this concept into something concrete and physical.

Leaving aside the question of precise dating, which is still unresolved – the debate concerns in particular the age of the oldest paintings – it is safe to say that between the fifth and the mid-seventh century AD the art of Kizil reached its height in the caves honeycombing the Muzat cliffs.

The walls of these caves hollowed out of friable rock offered a good base for paintings produced using both local resources and proven techniques borrowed from India and Afghanistan. First, panels hewn into the walls were smeared with one or more layers of clay mixed with animal hair (goat, camel, etc.), chopped straw and vegetable debris, to which was added a binding agent such as apricot juice or glue prepared from skins. When these layers had been smoothed down, a coat of white stucco (made from powdered lime and gypsum) was applied and carefully polished, sometimes using an ivory tusk. The support prepared, the artist

29

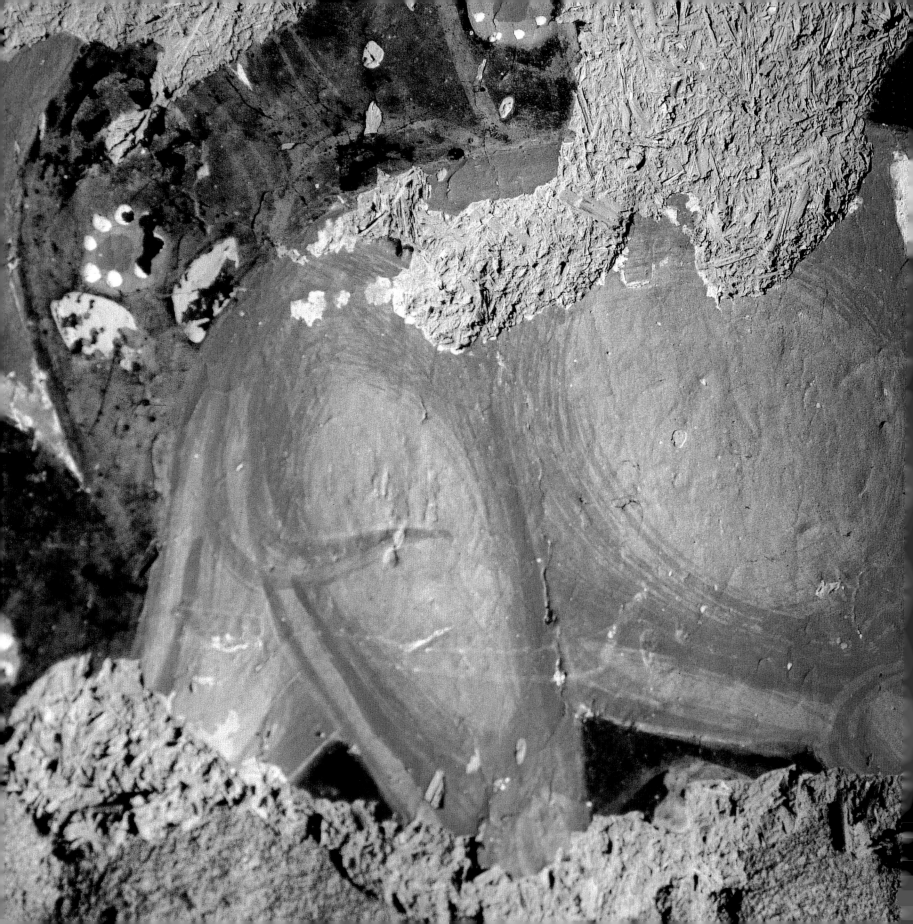

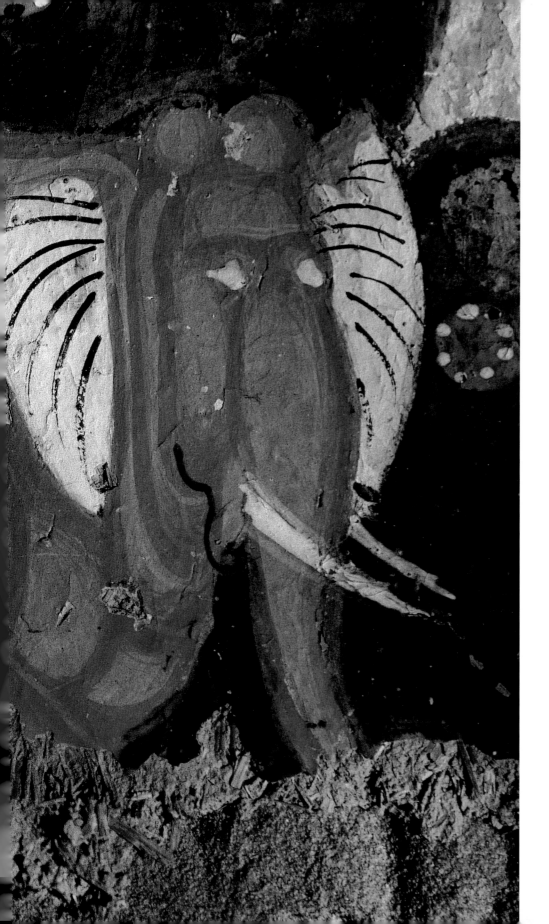

Lapis-lazuli elephant

The grace of this elephant derives not so much from its line as from its colour - the intense blue of lapis-lazuli. The ears and tusks anticipate the Chinese style, but the originality of the work depends on the use of lapis-lazuli to increase the animal's impact. Usually, the transport of this stone, which was extracted on the borders of Iran, would have been paid for by very wealthy patrons. For the famous rock paintings at Dunhuang, the Chinese had to use azurite. A master painter probably sketched out the design on the plaster layer, either freehand or with the aid of brown-black or brown-red pounces applied through a perforated pattern, and his assistants would then add the colours. [Maya Cave III]

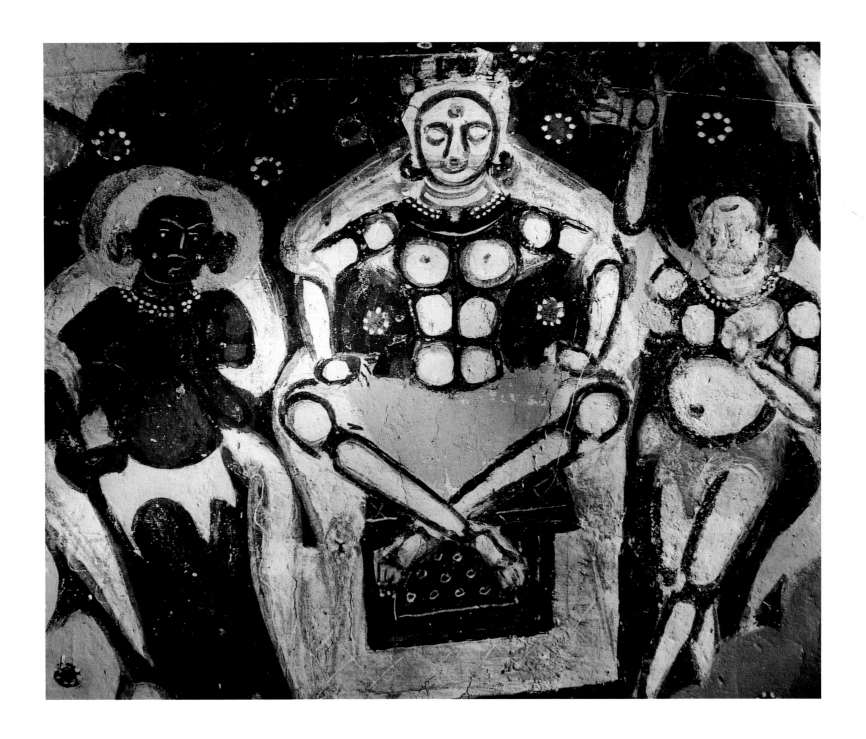

32

made a broad, freehand sketch of the design, or used a pounce-pattern. The colours, mineral- or vegetable-based, and varying according to the style and period, were then applied to the prepared surface. In the so-called second Kizil style, known as Indo-Iranian, the browns and ochres were frequently eclipsed by a lustrous lapis-lazuli most probably imported from the mines of Badakshan and used in great profusion, and by a dark green derived from malachite. When seen within the dark confines of the caves, these colours must have heightened the sense of contrast between the coolness below ground and the arid heat above, conjuring up, in the minds of the faithful, visions of a celestial world.

This second period (c. AD 650) is also characterized by the use of lighter, more vibrant tones. The modelling of the flesh and the well-defined folds of the drapery are painstakingly shaded, and outlines are heightened with brownish red or black. The details of the jewellery and hairstyles are picked out in gold, a few traces of which remain, the metal having been applied in powder or leaf form.

Another Indian tradition can be seen in the depiction of figures. Musicians or gods, placed side by side, are differentiated by contrasting skin tones: some light, some dark with the bridge of the nose, neck, eyebrows, eyelids, earlobes and chin picked out in white. Sometimes, the dark flesh colours are boldly executed in a beautiful bright blue, producing an incredibly modern effect, reminiscent of the Fauvism of Derain or Matisse. This palette is very much in evidence in Maya Cave III.

The Kizil style changed during the seventh century. The modelling became more conventional, and a tendency towards abstraction is noticeable on the vaulting, where multifoil shapes are used to represent mountains.

The 'Chinese style' is not in evidence at Kizil, where Indian, Gandharan and Sogdian influences prevail (except in Cave no. 1, recently opened up by archaeologists). It is, however, to be found at Kumtura, where *apsaras* – flying nymphs portrayed in stylized and graceful poses – are painted in a different palette: ochre, light green and, especially, vermilion, outlined with strokes of brown or black. Their flowing

Iranian influences

Maitreya, the Buddha of the Future, is seated on his throne, flanked by two bodhisattvas. His crossed legs recall the elegant posture employed by high officials of the ancient Sasanian empire. This Iranian influence may be connected with the presence in Kizil of the last Sasanian emperor, who took refuge there. The Indian style tends to be more sensual; the mannered attitudes of these figures are characteristic of Central Asia. [Cave with the Bodhisattva Vault]

costumes betray their Chinese origin, as do their streaming scarves and *dhotis* (a kind of skirt worn by divinities) whirling in totally surreal fashion across the vault. At Kizil, as at Kumtura, certain caves contain examples where the musculature of the body is expressed in dark tones with black outlines, whilst the skin tones are a chalky white.

The frequent use of pounces in no way restricted the astonishing freedom with which the artists wielded their brushes to express individual features, such as a monk's beard or the beating wings of a bird. It is this freedom that is so captivating to the modern eye.

Laure FEUGÈRE

The Indian tradition

The use of contrasting flesh tones, often heightened by the use of black outlining, recalls the Ajanta frescoes. [Cave with the Bodhisattva Vault]

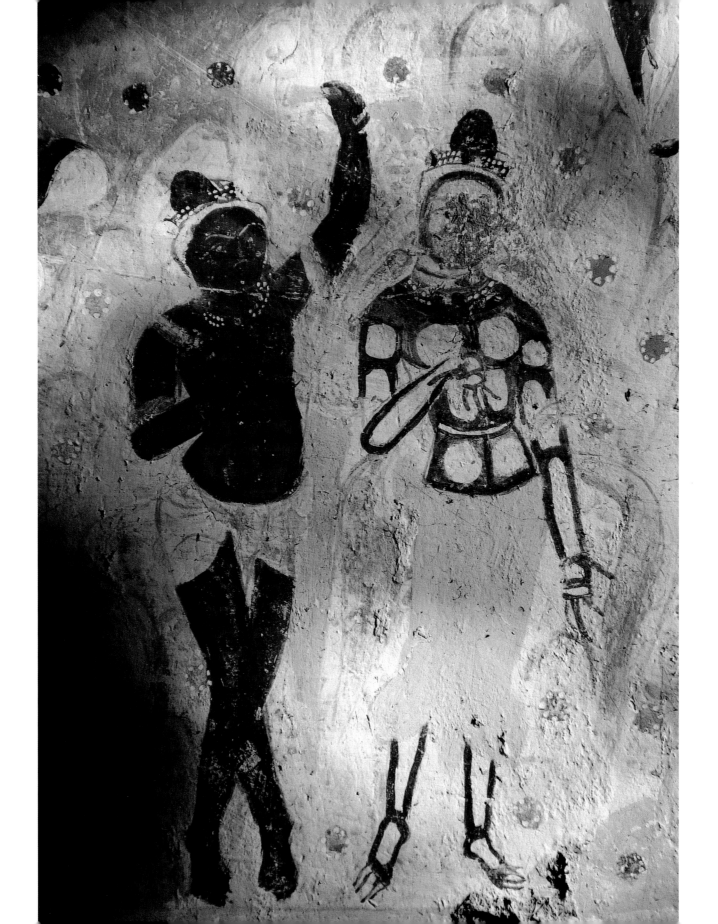

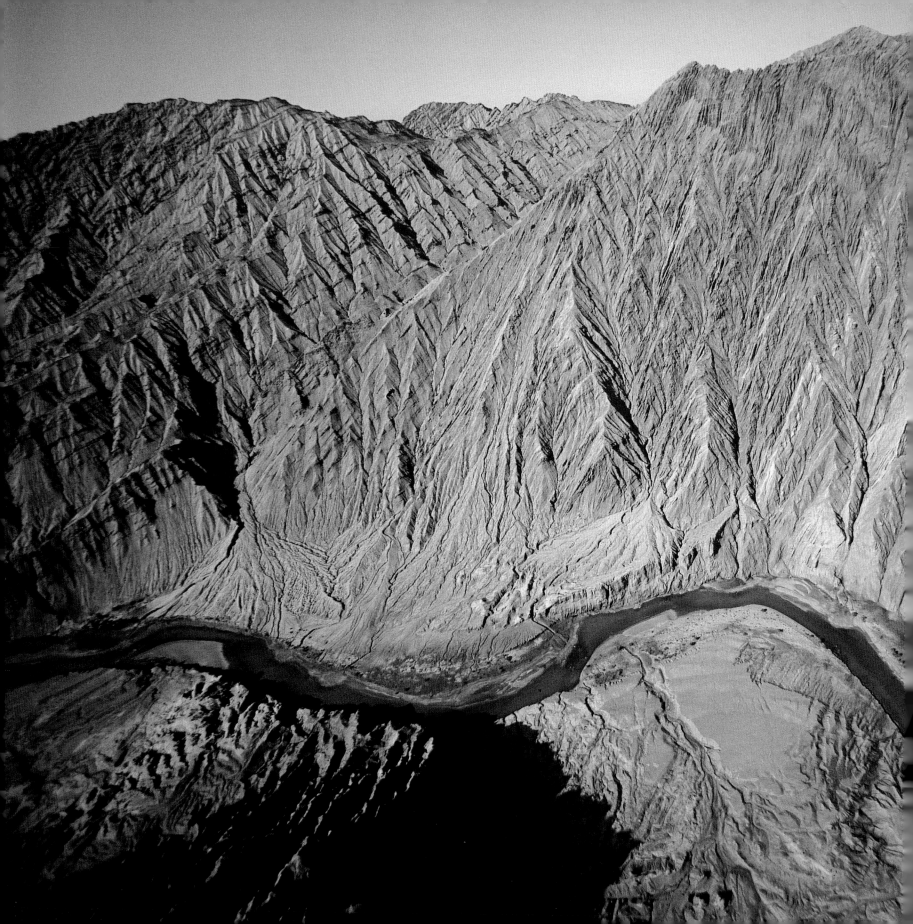

IN THE HEART OF SERINDIA: THE KINGDOM OF KUCHA

The ancient kingdom of Kucha has left exceptionally rich traces of an ancient and brilliant Buddhist culture which blossomed from the third to the eighth century AD. Kucha's unique historical importance is best explained in relation to the region of Serindia and the Silk Road as a whole. It occupied an almost ideal position on the Northern Silk Road: halfway along the caravan route linking the city of Kashgar – facing the Pamir mountains in the west – to Dunhuang in the east, just beyond the Jade Gate at the border with Chinese territory. These two meeting points of the old trade routes mark the limits of Serindia proper. We know about Kucha principally through its Buddhist art and from the reports of Chinese monks who travelled through the area on pilgrimage; there are few direct written references in the form of manuscripts or inscriptions and graffiti on temple walls. Another important source are the references, mostly oblique, in Chinese historical annals. The land of oases that is now the modern province of Xinjiang retained a cultural unity, coloured principally by Buddhism, for over a thousand years, from the first or second century to the eleventh century AD. Today, archaeological discoveries have made it possible to distinguish this region from the vaster and more indeterminate geocultural complex known as the Silk Road. Serindia proper constitutes the eastern section of this network of intercontinental trade, ending at the central plains of China: a region characterized by mountains and deserts, bounded by western China and north-eastern India. The name Serindia is of ancient origin and probably goes back to Procopius of Caesarea in the sixth century AD. It reappears in the writings of French geographers of the 1800s and finally acquired official status through the work of the archaeologist Mark Aurel Stein, one of the pioneers in this field.

The cliffs at Kizil, a major archaeological site in the kingdom of Kucha.

37

Buddhism: relay stations of a religion

The Northern Silk Road had one feature in common with the southern route: on the edge of the Taklamakan Desert, they both skirted the foothills of the great mountain chains surrounding the Tarim basin – the Tianshan range to the north and the Kunlun to the south. The terrain and the extreme climatic conditions account for the routes taken by these two virtually unique roads. One oasis succeeded another along their length, forming more or less compulsory halts; these oases boasted developed facilities, and some of them grew into city-states at the heart of the Central Asian kingdoms that flourished at the height of the Buddhist era. During the eventful history of Serindia, the two routes – particularly the northern one, which, fairly early on, around the fifth or sixth century, became the more frequented – were used not only by merchants and proselytes, especially Buddhist monks on pilgrimage, but also by various conquering armies. In the wake of these expeditions followed civil populations, entire peoples forced to take the road into exile far from their ancestral or adopted lands. There is a long list of these, from the Yuezhi (first mentioned around the second century), who were expelled from western Gansu by the Xiongnu and ended up in Bactriana, to the Uygur Turks – themselves conquerors of land, at one time of all Serindia – who were in turn overthrown at the start of the eleventh century by the Tangut (related to the Tibetans) and made to retreat further south-east, to Nanshan. Apart from a few exceptions along the ever-changing course of the Tarim and its tributaries, or on the ephemeral banks of the Lob Nor, the hinterlands where life could be sustained were limited to the area between the high mountains and the central desert of the Taklamakan, both of which were extremely difficult to cross.

It was in these narrow, discontinuous fringes that the oases were extended and developed. The traditional art of irrigation, practised by all the non-nomadic peoples of the region, as far afield as Transoxania, enabled them to turn these

oases into veritable cities. If the kingdom of Kucha (Chinese: Qiuci) was far from being the largest of these communities along the northern route over a long period of time, its cultural and religious influence – or rather its religious culture of the very highest order – assured it a major role in the history of the spread of Buddhism in Central Asia. Amongst the Serindian states, only Khotan, on the southern route, enjoyed comparable fame: like Kucha, it was a major halt for Chinese pilgrim-monks 'in search of the Law (the Doctrine)' in the lands to the west (*xiyu*).

Pilgrims and masters

Having glanced at the vast expanses and the civilizations east of Kucha, let us now turn our attention in the other direction – without forgetting that Kucha, in its ideal position, occupied the mid-point of the northern route. To the west of the kingdom was the state of Shule, as it was called in Chinese, or Kashgar in the later Turkish language. Here was a meeting-place, we recall, of the two caravan routes skirting the Tarim basin before crossing the Pamir mountains. The historical importance of the principality is attested by much contemporary evidence of the influence of Buddhism, but Kashgar was also one of the first 'kingdoms' of Serindia to fall to Islam and to see its celebrated Buddhist past overwhelmed by a new dynasty of rulers.

Kashgar was an important stop for Chinese pilgrims journeying on to Bactria, Sogdiana, the plains of the Hindu Kush and India. Other accounts shed light on the schools and doctrines which, if they did not originate in Kashgar, were at least taught there at a precise point in time and contributed to the city's importance in that period. Between Kucha and Kashgar, archaeology – rather than historical evidence, which is curiously absent here – has revealed the existence of a large monastic and cult complex, probably connected with an embryonic city or, in the

On the narrow fringes of the Taklamakan Desert, a chain of oases developed into royal cities such as Kucha. The Silk Road wound along the foothills of the great mountain chains encircling the Tarim Basin.

simplest imaginable form, a caravanserai commanding a pass in the Tumshuq area, not far from Aksu. It was discovered by the French archaeologist Paul Pelliott, who, in 1906, unearthed the remains of monastic structures and *stupas*. The significance of these religious foundations lies not merely in their size, but also in the length of time they appear to have been occupied. For instance, the original site of the monastery had clearly been extended at a later date by the addition of temples to the north. These facts, combined with the presence of some major works of Buddhist art – monumental sculptures formed of dried earth, moulded, shaped and applied to the walls of the buildings to create large-scale reliefs – make the site one of the most important discoveries in Serindian history.

How did this Buddhist centre escape the notice of the Chinese monks, always on the lookout for important pilgrimage halts, major religious sites and noteworthy monastic communities? Perhaps, as the silence of the texts appears to suggest, the Tumshuq complex, compared with its neighbours, had no interest for those in search of sacred places. References by pilgrim monks are, of course, selective. They were mainly concerned with recording religious events, visits to time-honoured holy sites, and the practice and study of particular branches of doctrine espoused there; sometimes they describe the sites themselves, when they are not giving details of their meetings with the teachers and celebrated Buddhist sages whose names they record. Their testimony enables us to sketch out a picture of

the geographical and cultural environment extending beyond Serindia in the strict sense – towards the Buddhist countries of north-western India – and casting light on the importance of Kucha in the Serindian Buddhist context.

Routes of transmission

In fact, the 'quest for the Doctrine' required these pilgrim monks to travel, as far as possible, to the sources of Budddhism. They therefore broke their journeys across Serindia in the regions of north-west India, Gandhara, Kapisa (in present-day Afghanistan), Bactria, and especially Kashmir, before arriving in north-east India, land of the Ganges and the historical setting of the Buddha's life. In the course of their travels, pilgrims of the fifth to seventh centuries (like Fa'shien and Xuanzang) followed, and returned by, one of the ancient and favoured routes by which the Doctrine had been transmitted to the Serindian kingdoms, and particularly Kucha. On this point, the evidence agrees that Kucha enjoyed special links with communities in Kashmir. Similarly, stylistic studies of Kuchean art – both painting and sculpture – suggest it was substantially influenced by the art of the north-western provinces, including regions of ancient Uttarpatha such as Hadda and Bamiyan (west of Gandhara), then at the height of their artistic achievement.

By the fifth century, the doctrinal and religious landscape of Kashmir had already altered somewhat, with, for instance, the development of a Buddhist form of yoga (Dhyana), related to the Great Vehicle but retaining numerous transitional elements. Nonetheless, for some time the chief source of inspiration for Kuchean monks continued to be one of the earliest living Buddhist traditions: Hinayana, the Small Vehicle, the doctrine of the Sarvastivadin sect which had been based in Kashmir from the first century.

The monastic community obedient to that tradition was, according to Chinese pilgrim monks, by far the largest in the Serindian kingdom; it remained so in the seventh century, according to that most reliable of witnesses, the monk Xuanzang, who set out for India in 627. The influence of Kashmir – like that of regions such as Kapisa and Bamiyan which now form part of Afghanistan – is an important factor in assessing many elements of Kucha's history, and, given the latter's dominant position in the Tarim basin, in understanding the conditions under which the Buddhist Doctrine and its expression in art were transmitted as far as China.

The monk Kumarajiva (344–413), a Kuchean of the second half of the fourth century, can be seen as the first and prime example of monk scholars facilitating the transmission of texts, art and culture, which was to become increasingly important over the next 300 years. The son of an Indian (a converted Brahmin) and a royal princess of Kucha, his religious education took place at a very young age in Kashmir (from 352), at his mother's request. The spiritual horizon of the young monk, formed by the doctrine of the Small Vehicle, was extended by study of the Great Vehicle, and particularly by the philosophy known as Madhyamakaya – 'Doctrine of the Middle Way' – which he learned at Kashgar on his way home to Kucha (355). On his return, he devoted himself to the study of these two traditions for thirty years or so, until the conquest of the city in 384 by the forces of the Sino-barbarian kingdom of the Anterior Qin dynasty. He was taken by the victors to Liangzhiou, a stronghold of Buddhist culture in eastern Gansu, and removed from there in 402 by the ruler of the neighbouring (Posterior Qin) kingdom to the capital Chang'an (now Xi'an). The king, who was an ardent Buddhist, gave Kumarajiva a large number of assistants to help him in the lengthy work of translating the Doctrine, a task that occupied him until his death about ten years later.

In this way, one of the most remarkable late fourth-century transmissions of Kuchean Buddhism to China took place by a roundabout process that transformed a famous teacher into a prize of war. Kumarajiva's abduction, and the important role it played in the spread of Buddhism, indicates the enormous fame that Kucha had acquired at the Chinese courts, at the risk of compromising its own religious future. The Chinese sources, written in an admiring tone in the early seventh century, describe events of three or four hundred years earlier. At that time the kingdom was subject to the empire of the Western Jin. Do the sources exaggerate Kucha's glories in order to magnify the triumph of its capture? Whatever the truth of this, they describe Kucha in grandiose terms: a city with impressive fortifications, an equally majestic royal palace, and, as far as religion was concerned, 'a thousand *stupas*', no less, were recorded.

A century later, in the preface to a translated collection of penances for nuns, the *Bhiksunipratimoksa*, it is mentioned that this Sanskrit code of conduct was obtained at Kucha. It is curious that so much evidence exists that Kucha was a flourishing centre of Buddhist studies, and yet its practical legacy – the transmission of a code of religious conduct – appears to be so disproportionately modest, and mentioned as virtually an afterthought.

The Serindian miracle

Establishing the date of the emergence of the Buddhist kingdom is crucial, as this will also enable us also to date the great works created by its artists, of which only the famous rock shrines and traces of monastic cities now remain. We need to know if we should attach any credence to the 'thousand *stupas*' (a formulaic superlative in Chinese) supposed to have existed in the third century. Similarly, while the first discoverers, Albert Grünwedel and Albert von Le Coq, dated the

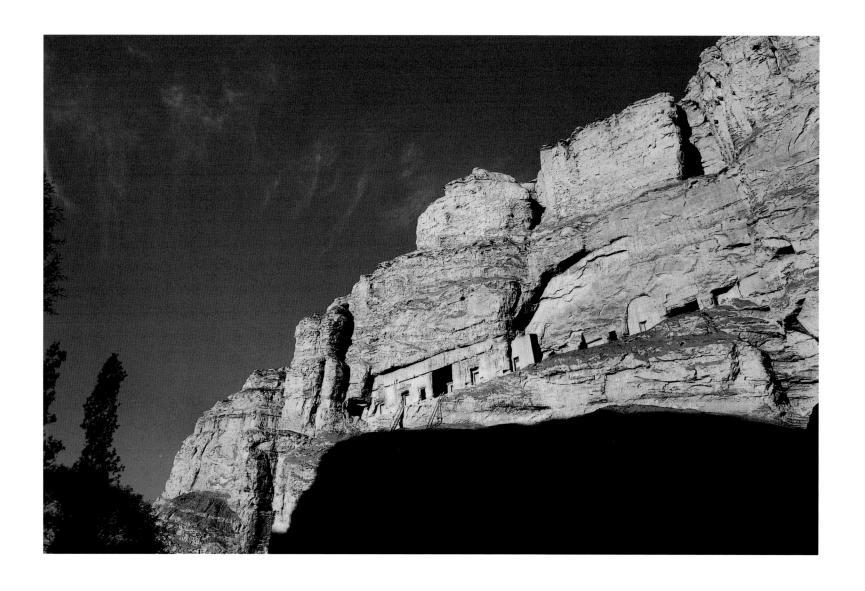

caves to the early sixth century, the archaeologists of Beijing University, admittedly on the basis of much greater evidence, are now proposing a date 200 years earlier. The matter is currently the subject of debate, and is of great importance for the history of Buddhism in Serindia.

Was Kucha no more than a step, however important, in the transmission of the Doctrine to China and the Far East? Tracing the patterns of influence establishes beyond doubt the pre-eminence of the regions situated to the west of Kucha: the

The steep cliff sides are pock-marked with the entrances to Buddhist cave shrines. After crossing the river, one is faced with a climb of some 250m (over 800 ft) up the crumbling rock-faces in order to reach them.

45

lands where the two Vehicles prospered and that were home to the Indian and north-western scholasticism that shaped its Buddhist history. These regions also appear to have played a part in formulating the doctrines adhered to by the most active communities – those one might reasonably expect to have provided the patronage for the artistic programmes of temples and shrines. Seen in this light, Kucha's indebtedness to these western influences is undeniable.

Are we therefore to conclude that Kucha played little part in the wider establishment of Buddhist doctrines and practices as well as in their artistic expression? Should we deny it an innovatory role of its own? A moment's reflection will show that no human society characterized, at any given moment in its history, by a dominant culture (including, for this purpose, religion) received from outside, has confined itself to imitating this culture and passing it on, without leaving its own particular mark upon it. Amongst the Serindian principalities, which as a group exhibited distinctive features not found in regions where Buddhism was long established, the importance of Kucha – like that of Khotan, but for different reasons – was clearly recognized by the Chinese. The evidence of social and religious links also strongly suggests that the kingdom exercised an equal attraction, though of a different kind, for Indian monks. To the states to the west, the kingdom must have appeared as a distant spiritual province, whilst for China, on the other side, it held all the fascination of a Central Asian land. For Chinese Buddhists, it was a source, closer than India proper, of scholastic traditions and monastic life. It is now clear that the same was true of its art. And for the rulers of China, Kucha represented a coveted stepping-stone in the further westward expansion of the empire.

The causes of Kucha's decline

A process of fusion – even confusion – seems to have operated in the assessment of the political and the spiritual influence of the Serindian kingdoms respectively. The height of their importance coincided with the era of the great pilgrimages to India by the most notable Chinese Buddhist monks. One of these was Xuanzang, who travelled through Central Asia to India between 627/9 and 645. Buddhism had at that time become established at the Imperial Court in China, and was enjoying its finest hour as a 'state religion'. This high profile under the Tang dynasty, which is probably a reflection of the cultural achievements of the Serindian kingdoms, coincides, ironically, with their most brilliant moment, just before these states went into a swift decline. The question then arises, should we see in this sudden decline a reason for the ensuing Chinese intervention in Central Asia? Certainly. Yet this intervention, the sure sign of a nation at the height of its power and supremely self-confident, could also be explained by the presence of rival powers in the region: the two Turkish khanates (Western and Eastern Tujue, which remained a threat until 744), and the young and ambitious Tibetan empire which entered upon the Serindian stage with the occupation of Khotan and Kucha between 670 and 672.

With the arrival of the Tang dynasty (618-906), the city-states, as in the past, immediately made attempts to regain their independence and free themselves from tribute to China. But the balance of power tipped first in favour of the Tang – who set out to reconquer the Central Asian kingdoms of Tarim from 640 – then, directly or indirectly, in favour of the Turks and Tibetans. In this struggle, where the destiny of the Serindian states was at stake, Kucha, like all the others, played its part. King Survanadeva (624–46) revolted against the Chinese overlords in

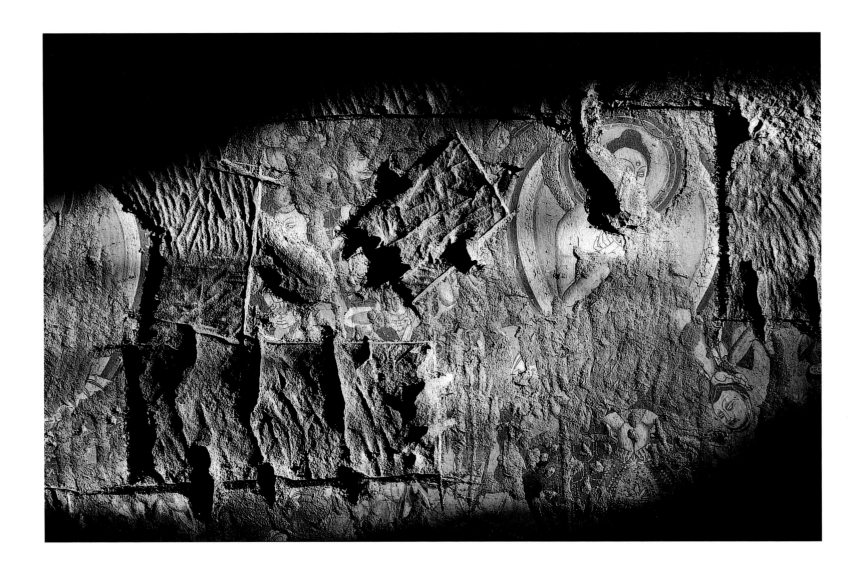

During one of the German expeditions led by Albert von Le Coq, samples of wall paintings were cut away in shapes that would fit the party's crates. [Maya Cave III]

644. But four years later, his brother, who succeeded him, was defeated. In 670 Kucha passed into Tibetan hands; a 'Chinese Peace' then followed, lasting until 751. Gradually, Serindia fell into the power of the Uygurs, and the Buddhist kingdoms were submerged by Turkish culture.

Archaeological discoveries

From the mid-tenth century, the majority of the populations of ancient Serindia underwent conversion to Islam, often forcibly, at the hands of the Karakhanid

Turks who dominated the western highlands of Central Asia. Along with Serindia there disappeared, with all its trappings, the brilliant civilization of the Buddhist kingdoms. Nine hundred years were to pass before, out of the silence and oblivion of the vast desert lands, the sacred harmonies of old were heard again in a kind of distant echo, as the remains of the temples and painted rock shrines of these ancient cities were restored to the light.

The archaeological 'discovery' of Serindia in the last decade of the nineteenth century was an international venture, led by scholars from Europe and Japan, and would remain so until the First World War. It began in 1888 with the discovery of a birch-bark manuscript bearing Indian writing, acquired at Kucha by a British officer, Captain Bower. Another manuscript of the same type, but older, inscribed in Kharosthi characters (an Indian script akin to Aramaic) was found at Khotan by the French expedition of Dutreuil de Rhins (1892). Of particular importance was the fact that scholars could now begin to see a coherent geographical framework connecting these discoveries: this was developed further by the Swedish explorer and geographer Sven Hedin in the course of his first expedition (1893–7). As Paul Pelliot would later remark: 'The hope arose that, in the sands of Turkestan … we would discover monuments of northern Buddhism that had disappeared from India.'

The first truly archaeological expedition, organized by the St Petersburg Academy of Sciences and led by Dimitri A. Klementz (1898), excavated in the Turfan region. Its results, including the earlier chance finds, were presented the following year at the 12th International Conference of Orientalists in Rome. On the same occasion the statutes of the International Association for the Historical, Archaeological, Linguistic and Ethnographic Exploration of Central Asia and the Far East, with headquarters in St Petersburg, were drawn up. This was a consultative body whose remit was to coordinate expeditions. At the same time independent national committees were established.

The next archaeologist to venture into this field of research was the Englishman Mark Aurel Stein (first expedition 1900–1), on behalf of the Indian government. Stein chose to excavate the ancient cities of the southern route. The cities of the northern route were targeted by four German expeditions (all given the generic title of Turfan Expedition, irrespective of their individual destinations). The first two – one under the Indologist Albert Grünwedel (1902–3), the other led by Albert von Le Coq (1904–5) – initiated and developed research around Turfan. Exactly contemponeous with the Grünwedel party was a Japanese 'religious' expedition (followed by two others). This was in fact a pilgrimage to the roots of Buddhism, led by Count Otani, the superintendent of a temple in Kyoto; it was the first international expedition to reach Kucha and the Kizil caves, and produced an initial survey of the sites.

In 1905 the first of several large-scale archaeological expeditions were sent to Central Asia. This year became a milestone in Kuchean studies, with the third German expedition under Grünwedel (1905–7), which was joined by von Le Coq from Chotscho (Gaochang, Turfan). At the beginning of 1905 the French committee decided to despatch an expedition to Central Asia led by the sinologist Paul Pelliott, who, between 1906 and 1909, concentrated on sites on the northern route skirting the Taklamakan. The French expedition was not repeated, despite returning with important finds. At the same time, Stein was undertaking his second venture (1906–8), in the course of which he revealed to the world the existence at Dunhuang of an extraordinary cache of documents relating not only to the religious life of that site but also to other monastic centres in 'metropolitan' China of a thousand years earlier. This seems to have been a period full of expectation. In those same years (1905–7), the above-mentioned archaeologists, together with Berezovskj (second Russian expedition), were working at the Kucha complex. The sites would be closed on the outbreak of the First World War; and by some sort of strange premonitory coincidence – but also building on the increased knowledge

provided by the earlier studies – working in the field on the eve of hostilities were the last missions from Germany (von Le Coq, 1913–14), Britain (Stein's third expedition, 1913–15), Russia (second Oldenburg expedition, 1914–15) and Japan (third expedition under Z. Tachibana and K. Yoshikawa, 1910–14).

Conservation of the sites

The archaeological map of the Serindian sites drawn up by these early expeditions revealed the scale and complexity of this area of research. Kucha, in particular, is a good example of the large, developed oases, incorporating extensive peripheral settlements at the height of its influence. The diverse nature of the sites soon became apparent. Excavations showed them to be scattered throughout Serindia, ranging from capitals of kingdoms or principalities to archaeological sites that were sometimes impressive, but not necessarily of prime historical importance.

In this way the archaeologists drew up an almost complete map of the major excavation sites. A definite division operated between the archaeological expeditions focused on the north and south routes: researchers had, for good reason, followed in the footsteps of the ancient pilgrims or Buddhist missionaries who had to travel by one or the other. In fact, within living memory, there were short cuts along dangerous tracks across the Taklamakan, linking Kucha and Karashar with Khotan, a southern route which only Hedin and Stein attempted. Buddhism was also transmitted along these routes, but the first archaeological finds suggested it was important to consider other connections. The *continuum* neatly described as the 'Silk Road' is in fact somewhat more complex, featuring various distinct 'cultural regions' within Serindia. Here, despite the distances involved, we find common, generic and evolving art forms, not one-off or occasional productions, which add up to a clear picture of artistic 'styles' that

are closely related to one another, and specific to the region. In this respect, Kucha and Khotan are seen to have been centres of a high Buddhist culture which reached far beyond the boundaries of the city-states themselves. This impression is confirmed by the discovery of literary evidence revealing the existence of linguistic regions prior to the great migrations of Turkish peoples. We can also distinguish, at the time of the Central Asian kingdoms, the western and central regions of the Tarim from those further to the east – imagine a line passing between Karashar and Turfan, on the edge of the Tarim basin – or which were already part of the Chinese province of Gansu.

After exploration ceased at the beginning of the First World War, it was Chinese archaeologists who made the first new discoveries. Over the last fifty years work has continued, using more systematic methods, with spectacular results. This research often involves the use of new scientific techniques to conserve the ancient sites of Serindia.

The discovery of the painted caves and the world-wide fame they have acquired has given rise to a dilemma. At stake is the transmission to future generations of a heritage that now belongs to all nations. The task presents enormous difficulties. In the region of Kucha alone, there are almost 40 caves at Kizil, a score at Kumtura, and 10 or so at Kizil-Qargha; further east, at Dunhuang, more than 450 have been found. Since the caves were opened, the air and light have begun to affect the delicate pigments of frescoes painted *a secco*, and some of the polychrome work has already degraded as a result. The problem is compounded by the increasing fragility of the rock (composite alluvial deposits) from which the caves were hollowed out.

Today, these prime archaeological sites in Turkestan are under the supervision of various conservation bodies, local and national, which have both a consultative brief and responsibility for direct action. The former is exercised by

two large regional institutions incorporating specialist departments of the Academy of Sciences. One has its headquarters at Urumqi, capital of Xinjiang, and deals with excavations in the autonomous Uygur province, including the sites at Kucha. The other, at Dunhuang – in tandem with a new research centre at Lianghzou – is charged with the study and conservation of the site proper, as well as related rock shrines in Gansu province. Over all these, exercising a central role of consultation and coordination, is the Chinese Academy of Social Sciences in Beijing.

Jacques GIÈS

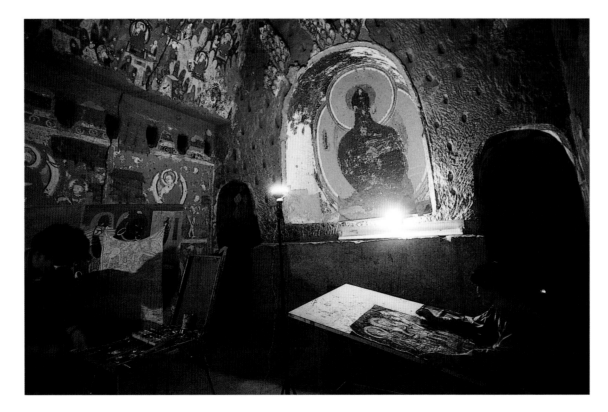

Chinese copyists reproducing panels and motifs in an underground 'studio'. [Cave 171]

▸▸ *Fragment of a painted panel viewed from the vaulted passage of Cave 171.*

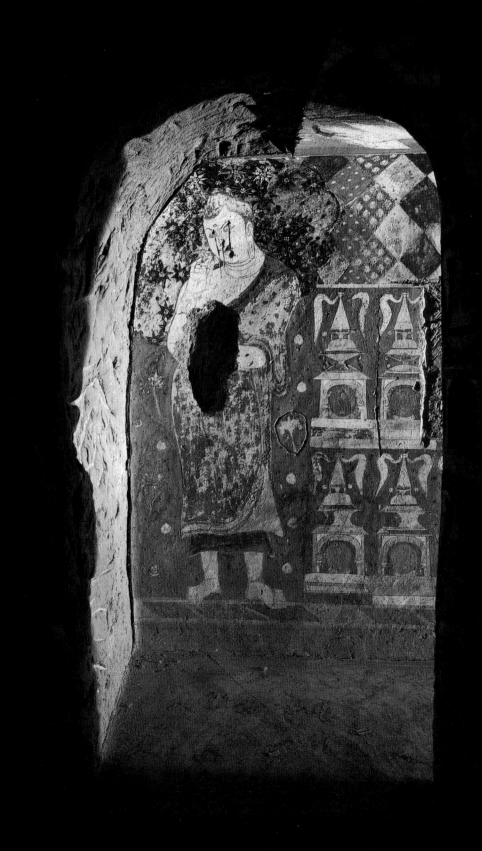

Symbols of the Buddha

On the walls and ceilings of the Kizil and Kumtura caves, the artist-monks narrated the legend of the Buddha in a way that could be understood by pilgrims. Their art, popular yet highly refined, also provides clues for deciphering the distinctive attributes of Shakyamuni, the Enlightened One. Careful examination reveals physical traits, jewellery and other objects that hold the key to his identity, as well as a language of postures and *mudra* (hand gestures). The visitor will discover an entire system of sacred symbolism – his or her initiation into the world of Buddhism.

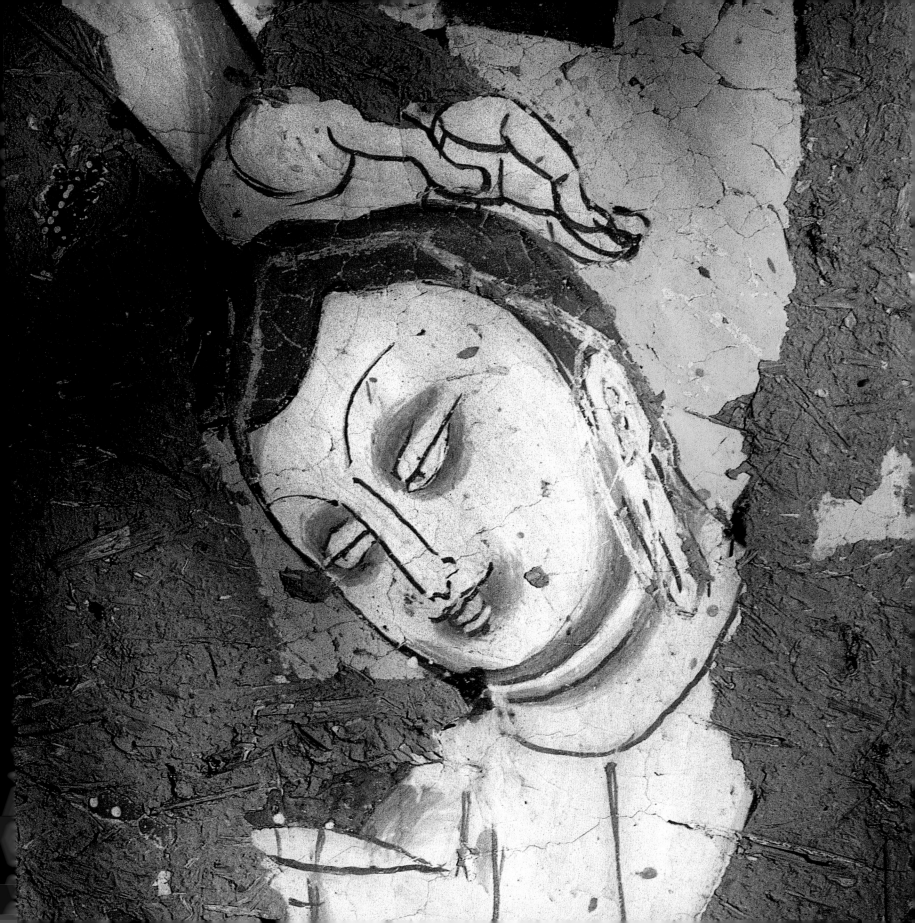

The Teaching of the Buddha

This fragment is a classic illustration of the Buddha instructing a disciple. The way in which he is portrayed here is a recurrent theme of Buddhist monasticism. Shakyamuni sits, legs crossed in the lotus position, on a simple throne (*asana*), its base draped with a carpet. His reddish-brown garment leaves the right shoulder bare; his left hand appears to make a gesture of giving. Though this gesture is not clearly defined, the dynamic relationship between the two characters is evident, and the scene decidedly lifelike. We are present at a sermon given by Shakyamuni to a young, shaven-headed monk, whose hands are joined in *anjali*, a mark of respect for his master. He too has bared his right shoulder out of respect – a customary gesture of a monk in the presence of a superior. The climate of Kucha was very harsh, and monks wore an outer robe above the inner, the same size, but a different colour. Here we catch a glimpse of the darker robe, forming a kind of revers.

A mandorla and halo of contrasting colours surround the Buddha and partly obscure the stylized flowering shrub which symbolizes the Bodhi Tree beneath which Prince Siddartha attained Enlightenment and became a Buddha. The background consists of a mountain landscape in the form of rocks, similar to that found on many ceilings in the Kizil caves. Attached to each rock is a pearl-like medallion, representing a flower. The neck of the Buddha displays the Three Folds of Beauty, while his ears with their unusually long lobes contrast with those of the young monk.

[Cave of the Pot of Hell]
◀◀ *[Maya Cave III]*

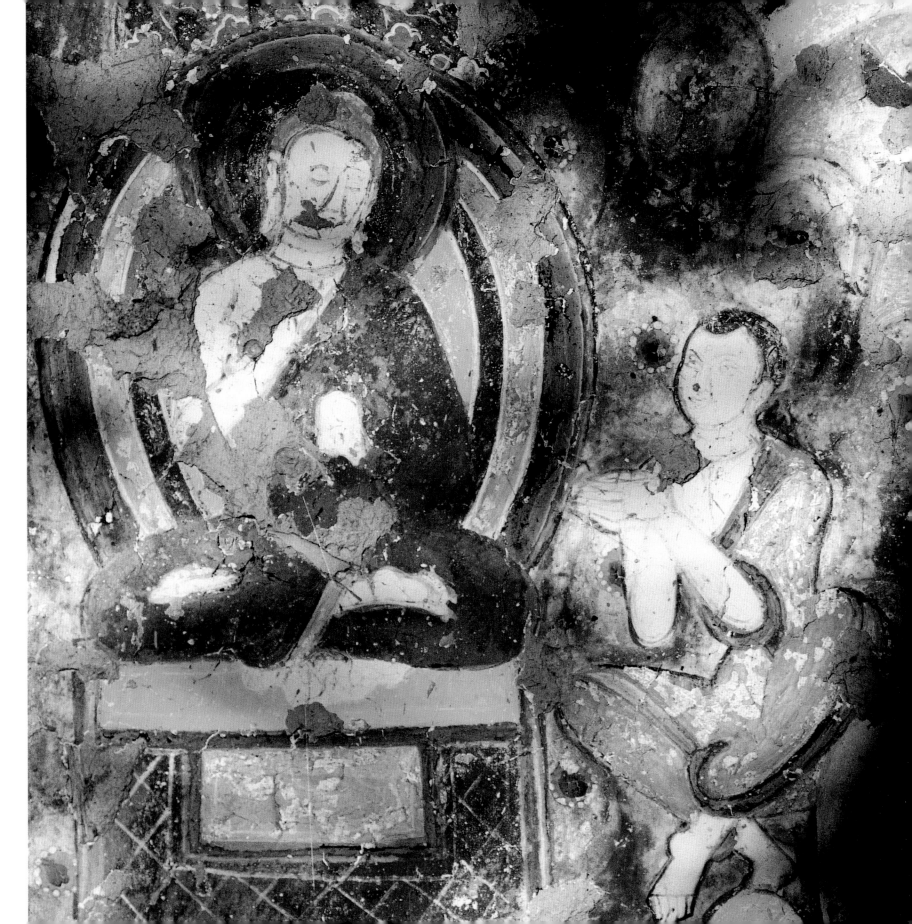

Signs of identity

The Buddhist texts list the physical characteristics that enable the Buddha to be instantly recognized. The most important of these *lakshanas* are thirty-two in number. Tradition has added eighty more, but these are secondary features and rarely figure in paintings or sculptures. The two traits most often shown are those indicating his status as the Enlightened One (the meaning of the word Buddha), and are known as the *urna* and the *unisha*.

The light of wisdom springs from a tuft of hair between the Buddha's eyebrows: the *urna*. This feature is often represented on statues by a cabochon of crystal or precious stone, and in paintings by a circle. The *unisha* is a cranial protuberance, the sign of wisdom and enlightenment. It is an interpretation of the princely topknot worn by Siddhartha before he renounced the world. For the Great Departure, he cut off his hair; this grew again, forming either wavy locks collected into a 'bun' on top of his head (Gandhara Greco-Buddhist style) or short curls twisting towards the right (the style of the Gupta period and the most common in India and in Kizil). These differences in Shakyamuni's topknot are very subtle and remain the object of much research. The hair is usually black, though blue is a common alternative.

[Chimney Cave]

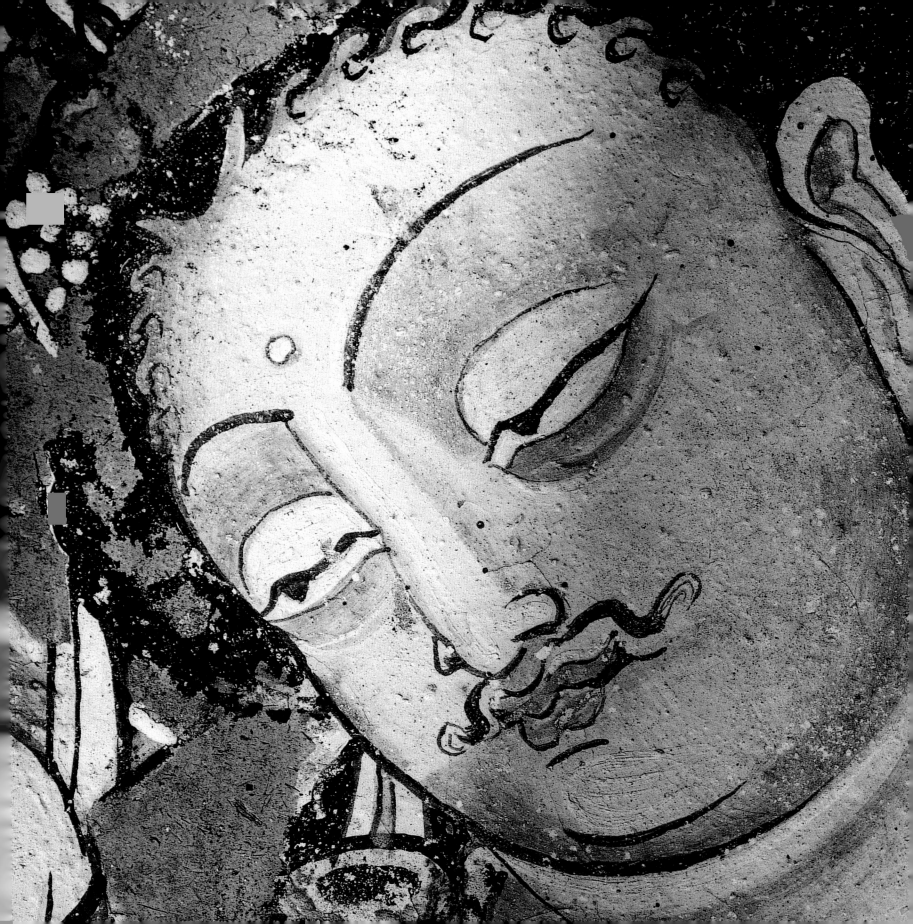

The double nimbus

Symbols of the 'light of the Buddha', the aureole (a circular halo) and the mandorla (almond-shaped) are usually painted at Kizil in blue or green monochrome. The colour gold is also used to express the radiance of wisdom and truth illuminating the body of the Enlightened One. In many examples, the face and neck still bear traces of gold. In South-East Asia, it is customary even today for the faithful to donate thin gold leaves which are applied to statues of the Buddha.

[Cave 14]

62

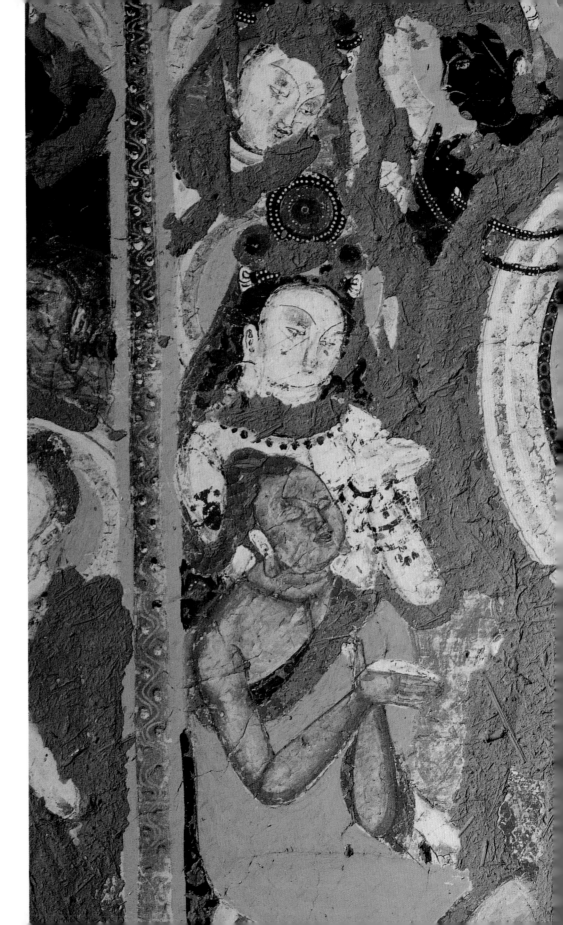

The face of the Enlightened One

The texts describing the Buddha's marks of beauty are full of poetic and startling comparisons: a chest like a lion's, legs like a gazelle's, very long arms resembling the trunk of a young elephant. These are not portrayed as such in the Kizil caves, but the faces bear other distinctive signs, such as highly elongated eyes shaped like lotus petals, a parrot-beak nose, deeply arched eyebrows, a chin formed like a mango pit. They reflect Indian models proclaiming the identity of the Enlightened One.

[Chimney Cave]

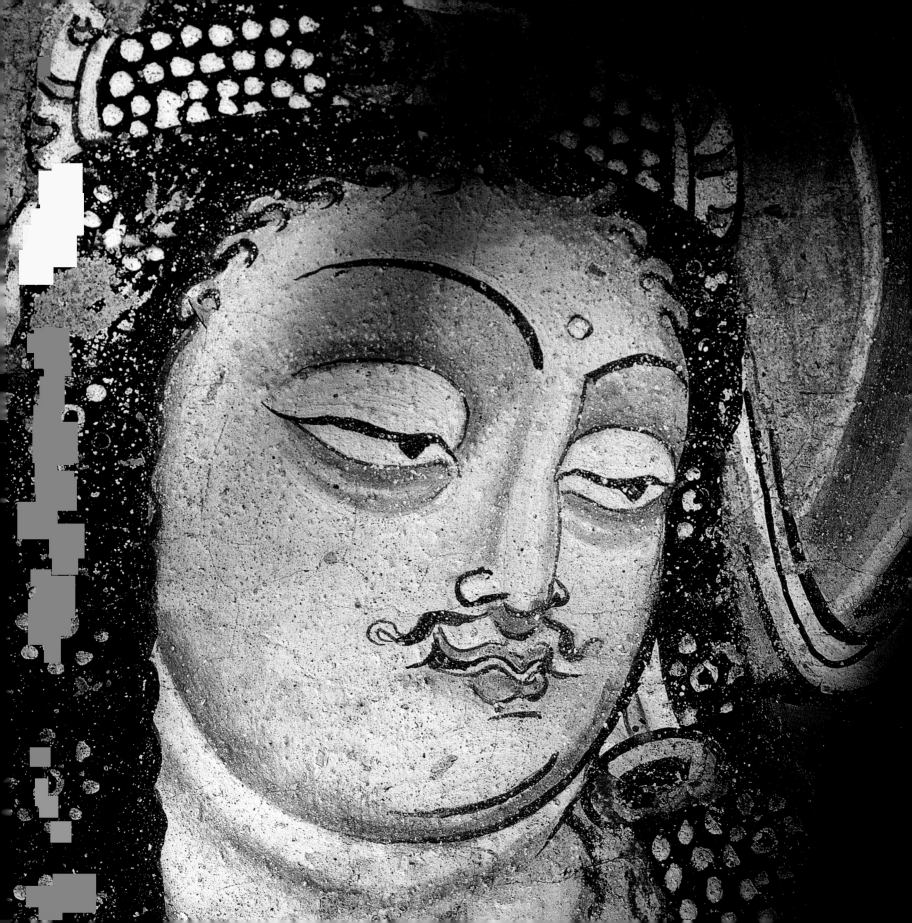

The Wheel of the Doctrine

Mudra – literally 'seal' or 'sign' – is a Sanskrit word designating ritual and symbolic hand gestures made by Buddhas and bodhisattvas. Most frequently depicted in the caves are gestures of preaching and disputation. Some forms of *mudra* are more complicated and refined, like the finger movements of the bodhisattvas on the cupola of the Kumtura shrine.

Here we see an example of *vitakamudra*, a gesture of the right hand used in disputation, with index finger and thumb joined. Another common gesture is *dharma cakra mudra*, similar to *vitakamudra*, which sets in motion the Wheel of the Doctrine in scenes of the Buddha preaching. The Wheel of the Doctrine may appear on the sole of the Buddha's foot or on the palm of his hand, but is rare at Kizil.

[Chimney Cave]

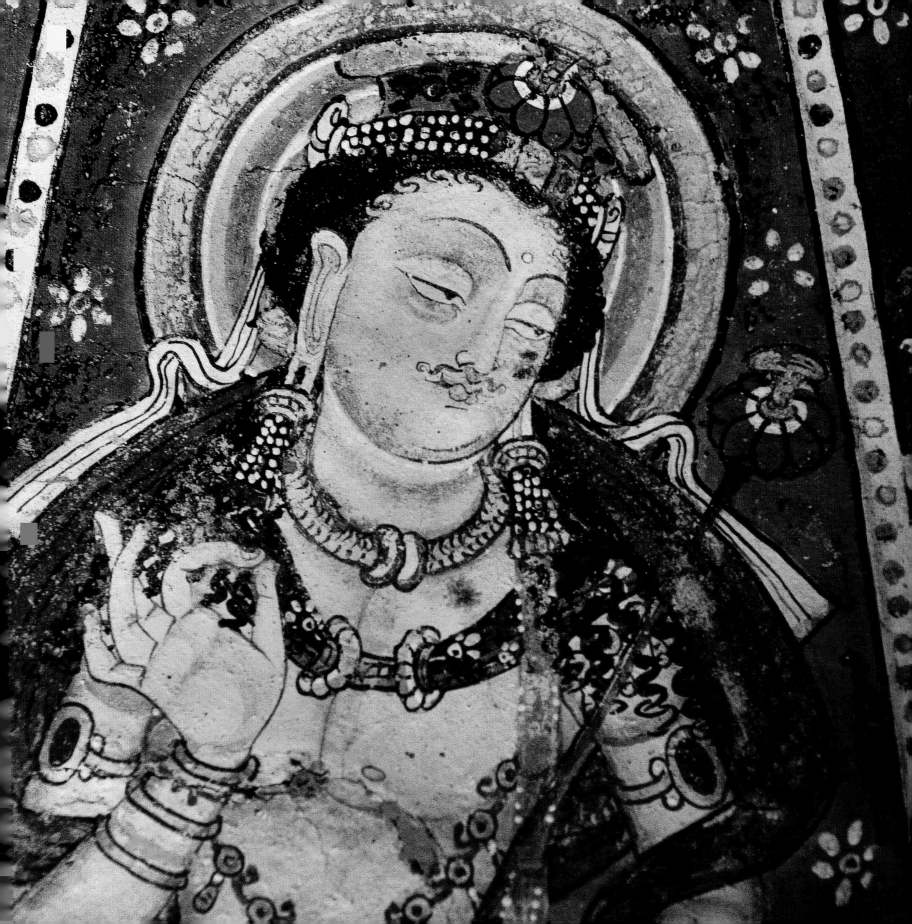

The ear of Buddha

Extremely long earlobes indicate the princely rank of the youthful Siddhartha Gautama, the future Buddha Shakyamuni. In fact, Indian princes wore heavy earrings that stretched the lobes. When Siddhartha entered the forest after the Great Departure, he removed his turban, clothes and jewels, exchanging them for the garments of a poor hunter; but the shape of his ears remained unaltered. The ears are always portrayed in this way. As a sign of respect, *arhats* (major disciples) and bodhisattvas are also depicted with elongated earlobes.

[Cave 171]

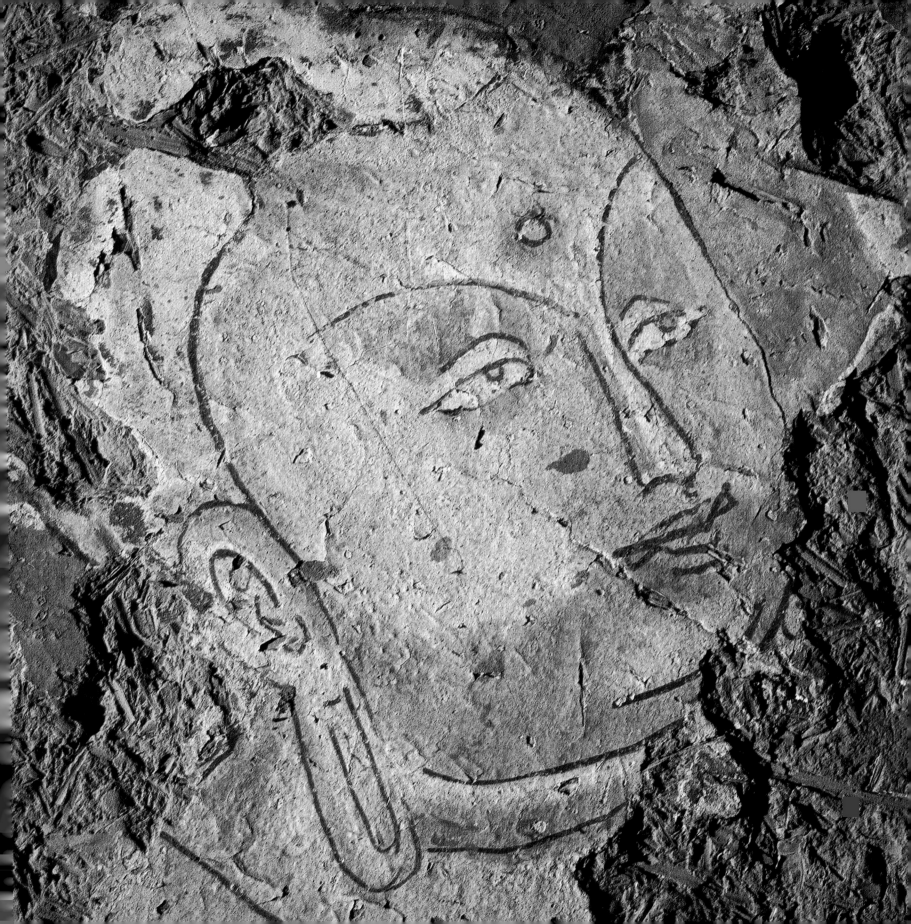

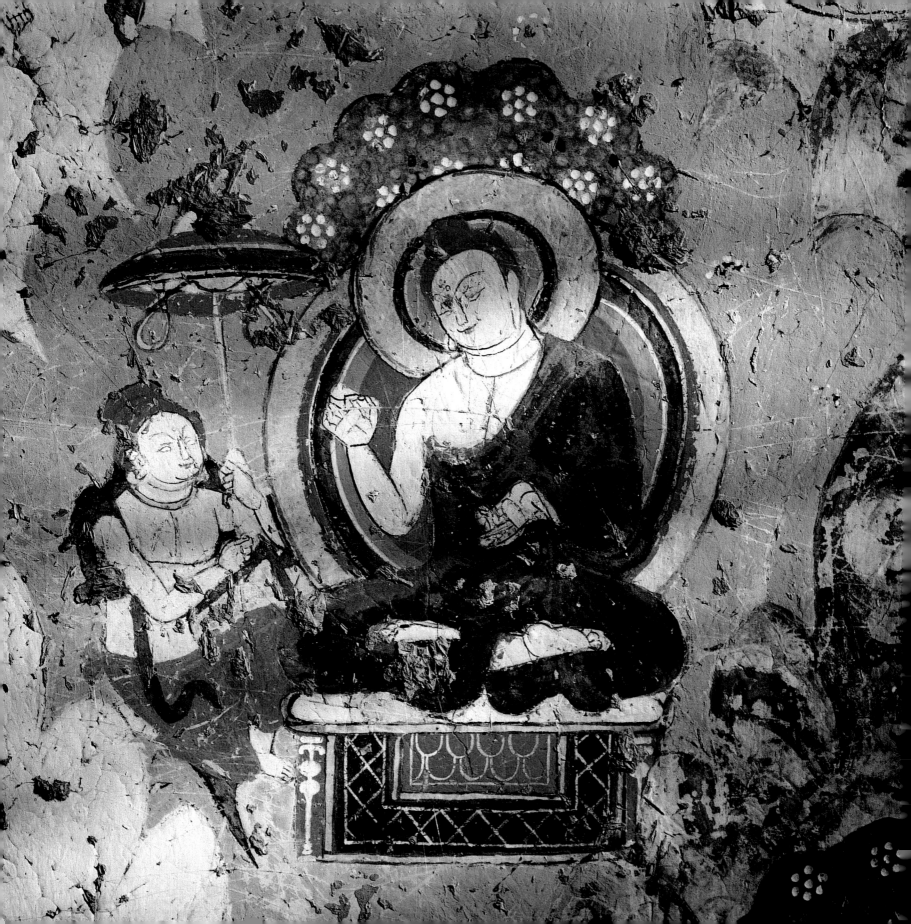

The parasol

A princely attribute, the parasol is seen with the future Buddha in scenes of the Great Departure. In some preaching scenes it acts as a baldachin or canopy.

In this delightful episode, on the vault of the Musicians' Cave, the Buddha is seated on a simple throne, conversing with a person in Indian dress who holds a parasol.

[Musicians' Cave]

73

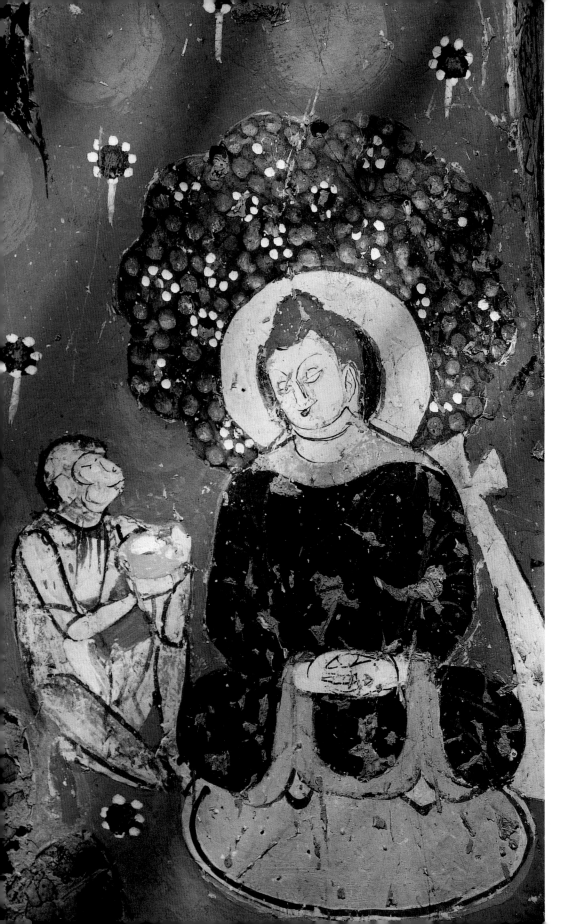

The gift of honey

A scene found some distance away on the same side of the vault as the previous image shows a monkey offering the Buddha a bowl. This is a reference to a legend in which a monkey who presented a gift of honey was so delighted to see his offering accepted that he danced with joy, slipped, and fell into the water. However, he was reincarnated as the great Indian monarch Ashoka.

[Musicians' Cave]

The monks' bowl

On the right-hand side of the vault in the Musicians' Cave we find Shakyamuni receiving a blue bowl offered by a kneeling prince. A bowl, sometimes shown with the Buddha, was the monk's sole possession, apart from his robe, and is still used to beg for food. Shakyamuni forbade his monks to own bowls made of precious metals.

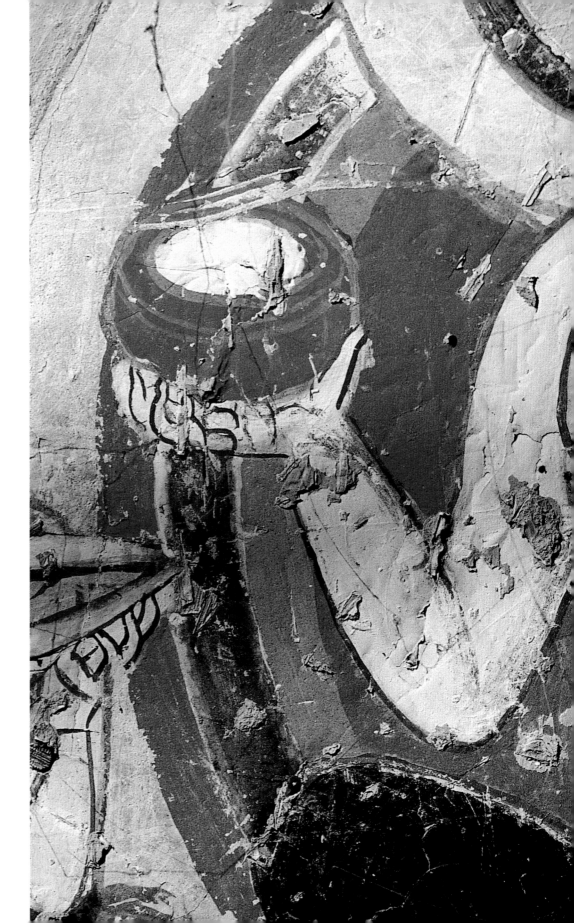

[Musicians' Cave]

The immaculate lotus

The fully opened lotus flower symbolized the Buddha even before he was portrayed in human form in episodes from his life. The roots of the plant delve down into the mud of the lake, but the flower remains immaculate and opens out in the sunlight, just as the human soul expands on contact with the divine. In such a way the 'Buddha nature' blossoms within a human being. This Indian symbol, which predates Buddhism, came to represent the Buddha as universal sovereign and often appears in the form of a throne with multiple petals.

(Right) On the roof of a cave, a rider in Kuchean armour is mounted on a white charger. Under each of the animal's hooves is a lotus. The scene may depict the Great Departure of Siddhartha from the royal palace of his father in search of spiritual fulfilment.

(Overleaf) The lotus unfolds right beneath the Buddha's feet in many scenes at Kizil.

[Cave 14]
▸▸ *[Chimney Cave]*

76

Postures of the Buddha

When preaching or meditating, the Buddha
is often shown seated with legs crossed.
When standing, his right hand tends to be
raised with the elbow bent, a gesture of
fearlessness, while the left, extended down
the side of his body, grips a portion of his
clothing. He adopts this posture on an
overhead frieze (right), as flames spurt from
behind his shoulders, hips and feet.
Elsewhere we see the Buddha walking after
his descent from the Tushita Heaven, where
he went to preach the Doctrine to his
mother, who died shortly after giving birth
to him. Later, when he subdues an enraged
elephant about to charge, he is shown
standing. He is only recumbent when in the
parinirvana position, lying on his right side
with his right arm folded under his head,
which reclines on a pillow, while his left
arm lies alongside his body. In this posture,
he awaits extinction: total *nirvana*.

[Cave of the Sixteen Sword-Bearers]

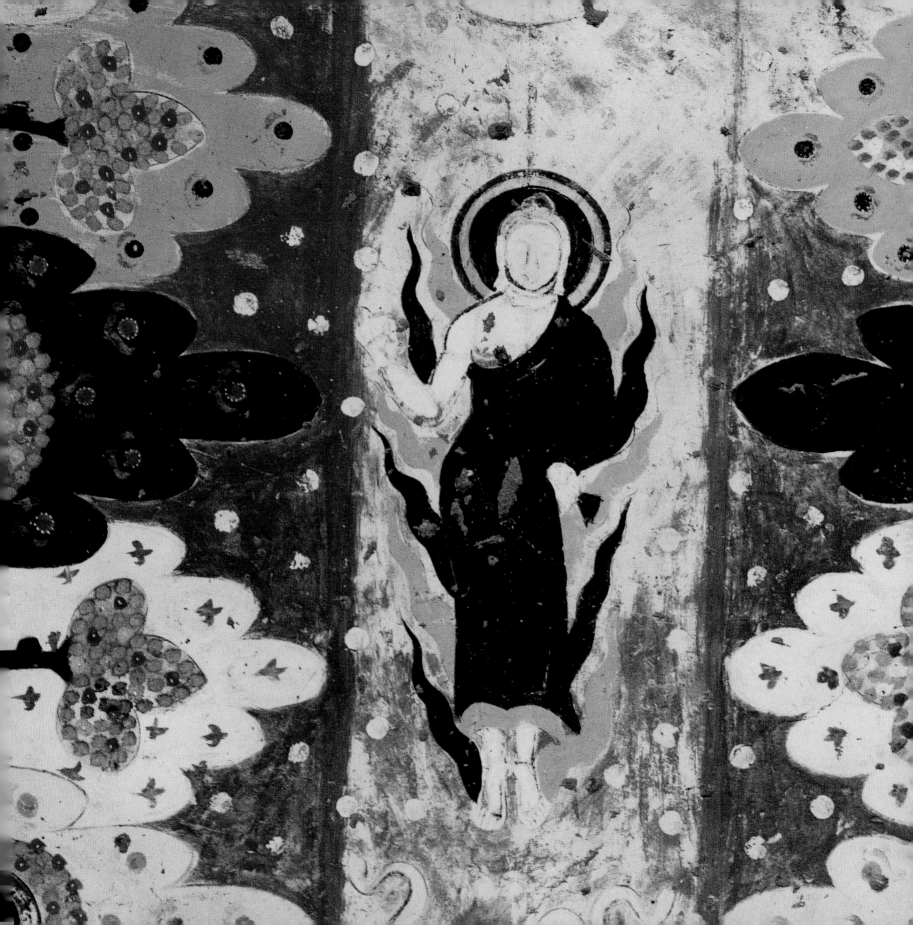

The *stupa*

The Buddhist monument *par excellence*, the *stupa* originally had a funerary purpose: it was a tumulus raised above the resting-place of the Buddha Shakyamuni's ashes. In fact, there were originally eight *stupas*: after his cremation, the Buddha's relics were shared out by the monk Drona amongst the kings. Erected at the most celebrated places of the Buddha's preaching, the *stupa* eventually became a symbol of the Buddha himself. Most monasteries or temples feature one of these reliquary monuments. The pilgrim venerates it by performing the rite of *pradakshina*, walking around it in a clockwise direction, like the visitor in the photo who has just circled the *stupa* to discover the Buddha lying in *parinirvana*. The oldest *stupas* belong to the era of the emperor Ashoka (third century BC), who is said to have had 84,000 of them of built. The hemispherical base is surmounted by a rectangular balustrade, in the centre of which is fixed a pole bearing parasols, the number varying according to period and region from one to thirteen, in decreasing size from bottom to top.

[Cave 1]

82

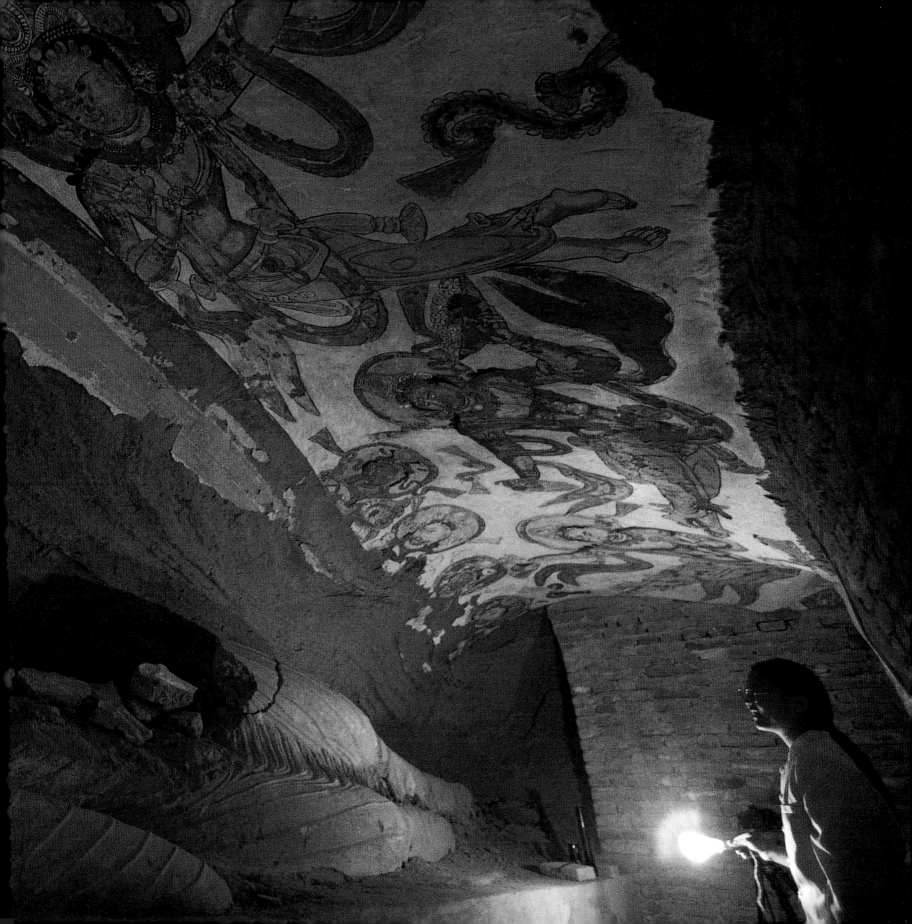

Past lives: the *Jatakas*

During his Awakening (Enlightenment), the historical Buddha is said to have recovered the memory of all his past existences, which he confided personally to his followers. These are recounted in about 500 *jataka* narratives, frequently depicted at Buddhist monuments throught Asia. At Kizil, more than eighty examples have been counted. Each *jataka* recalls a scene from one of the Buddha's past lives, during which he is said to have undergone various animal incarnations before assuming the human form of a bodhisattva, a Buddhist saint who aspires to *nirvana*. Recurrent myths or popular fables in many Buddhist countries, each of these epic tales illustrates the theme of extreme compassion, sometimes even involving the sacrifice of the body for the good of others.

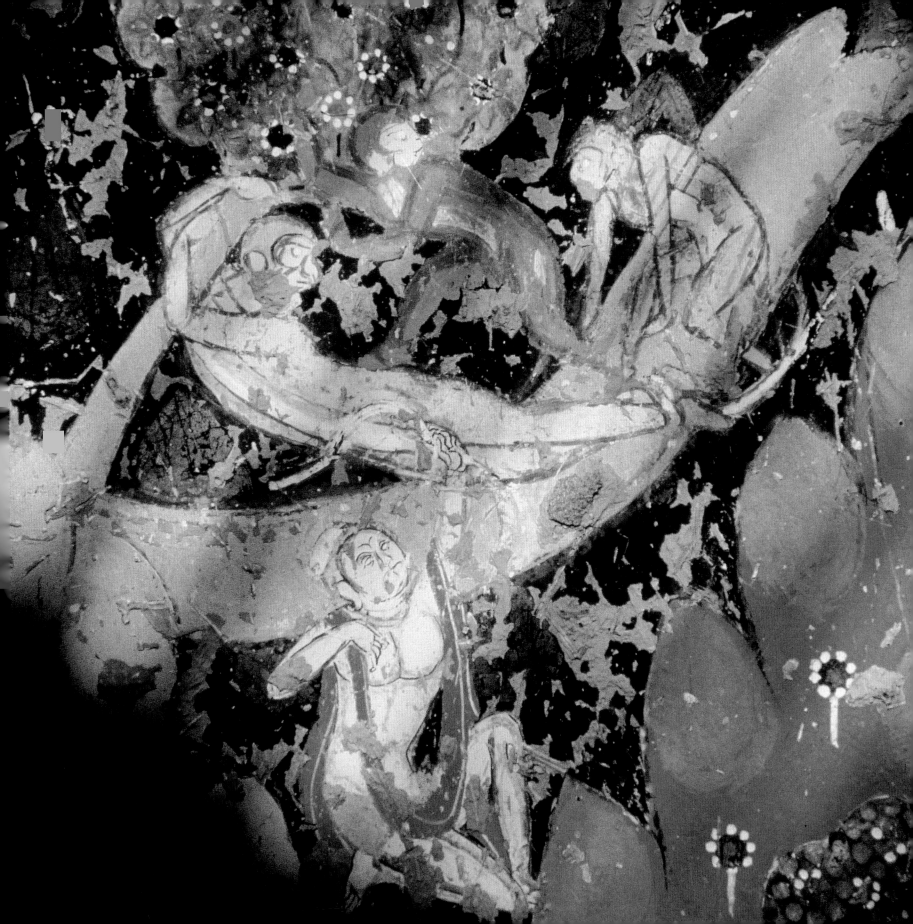

The filial devotion of a young ascetic

Shyama, a young ascetic, looked after his blind parents who lived in the solitude of the mountains. One day, on his way to fetch water for them, he was accidentally killed by a king out hunting. In this painting we see the young man kneeling beside a pool, while the king, riding (without stirrups) on a white horse, aims an arrow at him. Before dying, Shyama forgives the hunter and asks him to take care of his aged parents. This is a very popular tale, examples of which are found also in other caves, such as the Cave in the Gorge.

[Cave of the Sixteen Sword-Bearers]
◀◀ *[Musicians' Cave]*

86

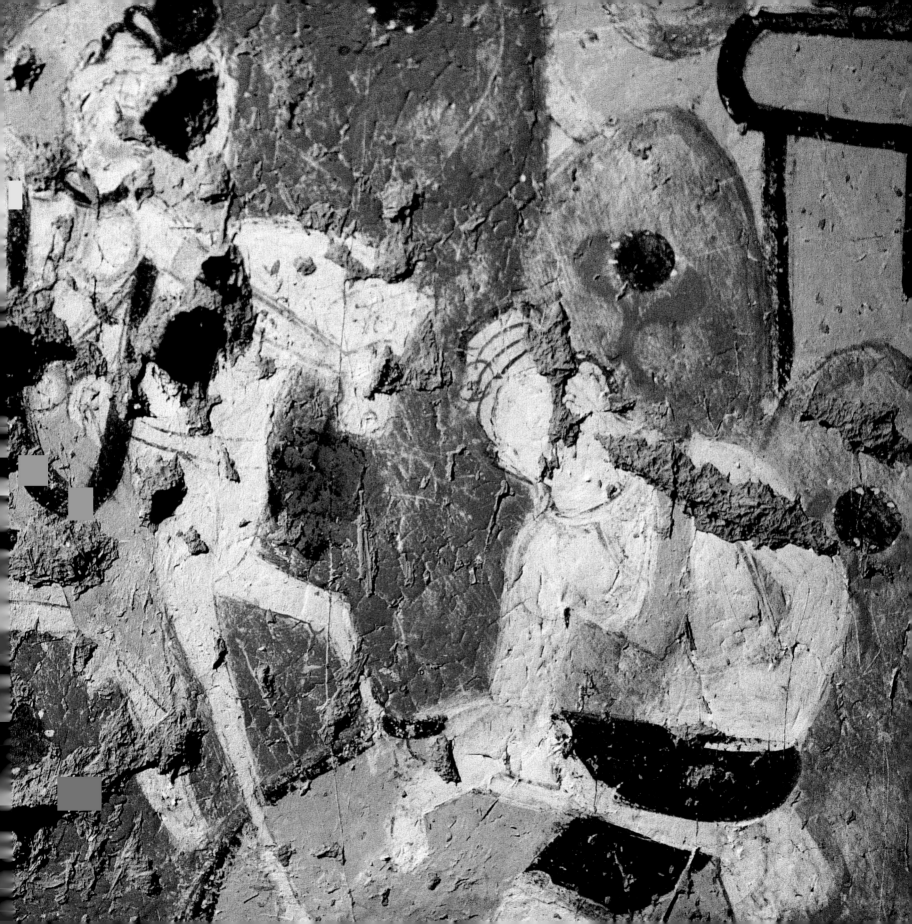

Hands of fire

In the Kizil caves, identifying the *jatakas* has involved an arduous work of decryption: the fables depicted on small, single panels are so condensed that they cannot always be deciphered with certainty. Grünwedel was the first to attempt this task. So far, three-quarters of the episodes have been identified. Comparisons with other sites and textual sources show that many of these scenes depict the self-sacrifices of the bodhisattva, handed down in Indian or Chinese texts or possibly transmitted by the pilgrims Fa'hsien and Xuanzang, who brought back local stories such as the one about the bodhisattva turning his hands into burning torches to guide a caravan lost in the dark.

The scene reproduced here is from the Cave of the Sixteen Sword-Bearers. The traveller wears wide trousers tucked into his boots, a long, close-fitting jacket and the white felt hat typical of the Khotan region and still worn today by the Kirghiz people. The caravaneer is followed by a large grey donkey.

[Cave of the Sixteen Sword-Bearers]

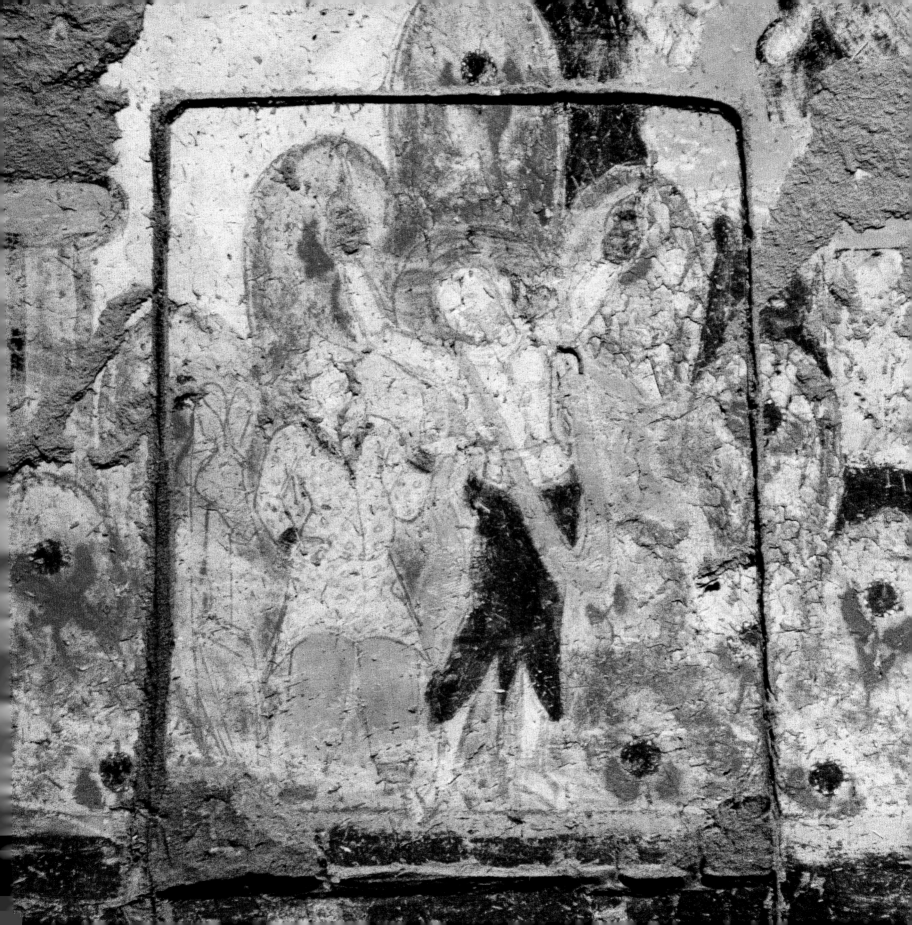

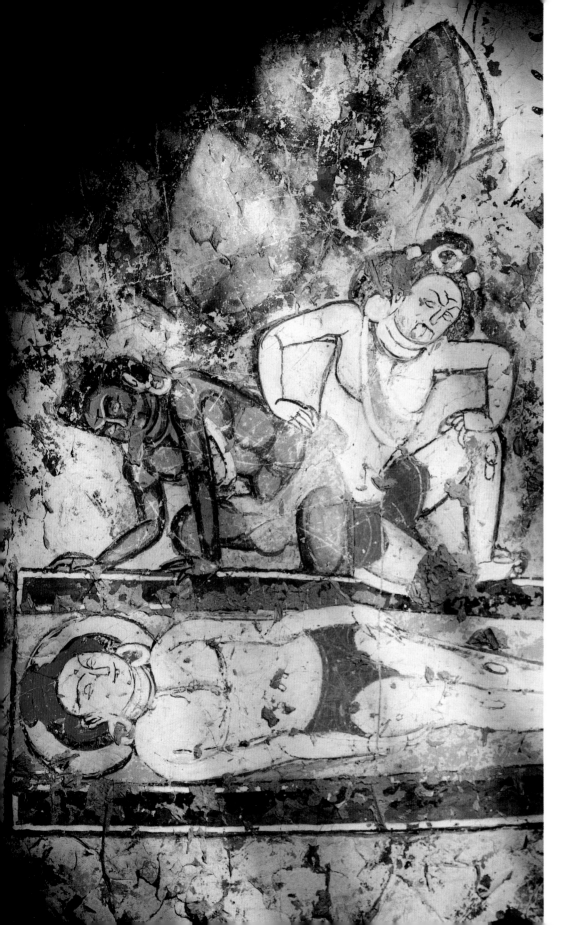

The secret of the dumb prince

In this scene, two men bend over a young prince, clad in a loincloth and lying in a pit. This is the tale of Prince Mupo, one of the 500 Buddhist narratives translated from the Chinese by the French sinologist Édouard Chavannes.

Mupo was the only son of a king of Benares. He was exceedingly handsome and loved by all, but no one had ever heard him speak a word, and his parents were worried about his silence. When he reached the age of thirteen, the king and queen approached a Brahmin for advice. The Brahmin declared that the boy was under an evil influence, and that he should be buried alive so that the king could have another heir. Everyone was grief-stricken. The prince, dressed in splendid robes, was handed over to the grave-diggers, who stripped him and began digging a tomb. He understood that he had been condemned because he was thought to be dumb. He went to bathe, and on returning cried out to the grave-diggers, 'What are you doing?' The men explained the king's order, and the boy replied, 'I am the prince'. The astonished grave-diggers ran off to tell the king the good news. Everyone rejoiced, and the king asked his son why he had remained silent for so long. The prince answered that, in a previous life, he had already been a king, and now, after suffering the torments of hell, he desired to become a monk and follow the Buddha's Doctrine.

[Musicians' Cave]

How the monkey people were saved

The story of Mahakapi, king of the monkeys, is retold in a large number of caves – here in the Musicians' Cave. To save his people, who were being chased by the King of Benares and his huntsmen, Mahakapi made a bridge from his body by suspending it over the river between two trees. This makeshift escape-route allowed the monkeys to reach safety. Exhausted, Mahapki died after all his subjects had crossed to the other side. The king of Benares, moved by compassion, gave up hunting.

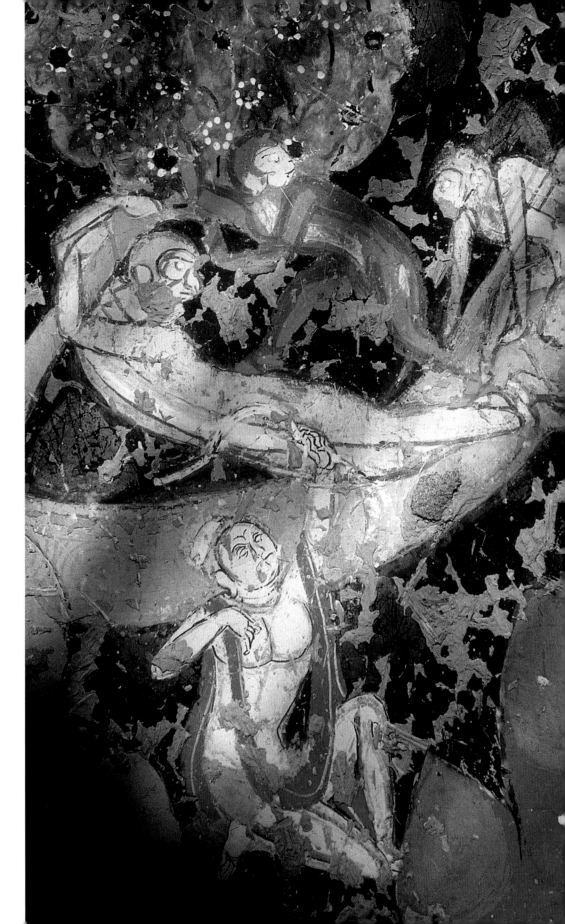

[Musicians' Cave]

The tigress's feast

This famous *jataka*, the story of the bodhisattva's sacrifice to a starving tigress, is found as far afield as the temples of Japan.

During a hunt, the bodhisattva noticed at the foot of a ravine a starving tigress who no longer had the strength to feed her cubs. Overcome by compassion, the bodhisattva threw himself into the abyss and offered his own body to the tigress as food.

The artist has caught the final moment of the sacrifice: the tigress, which here looks more like a black panther than a tiger, is devouring the holy man. The scene appears frozen in time, with the bodhisattva's scarf still floating in the wind.

This subject is found in several caves, including the Cave with the Bodhisattva Vault.

[Cave of the Sixteen Sword-Bearers]

92

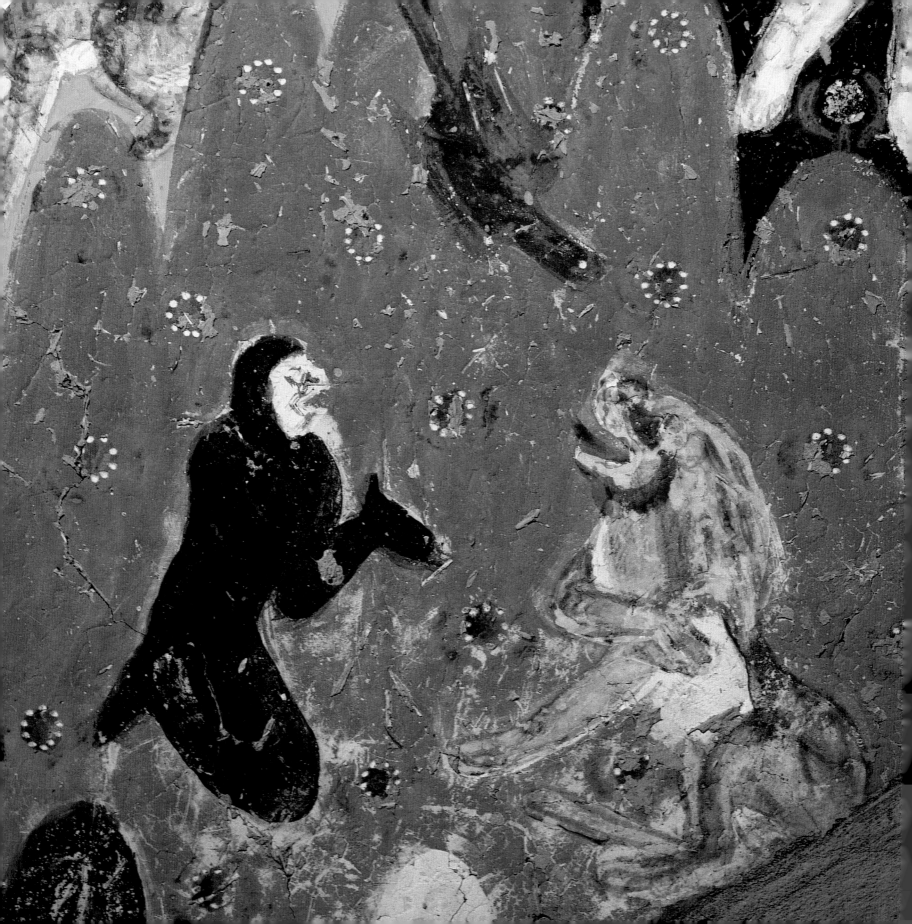

The lion, the eagle and the monkey

The *Simhakapi avadana* is very popular. An *avadana* is a Buddhist legend outside the narrative tradition of the *jatakas*.

This one tells the story of a lion to whom a monkey entrusted the care of her baby. The lion was unable to prevent a hungry eagle from snatching the little one. He asked the bird to release its prey. The eagle agreed to exchange the monkey in return for the lion himself. So the lion let himself drop from a rock and offered his life to save his charge.

In this scene from Cave 14 (left), there is a touching depiction of the injured lion gesturing with his paw. Although not a *jataka* in the strict sense, this tale is another example of the recurrent theme of self-sacrifice.

[Cave with the Bodhisattva Vault]

◀ *[Cave 14]*

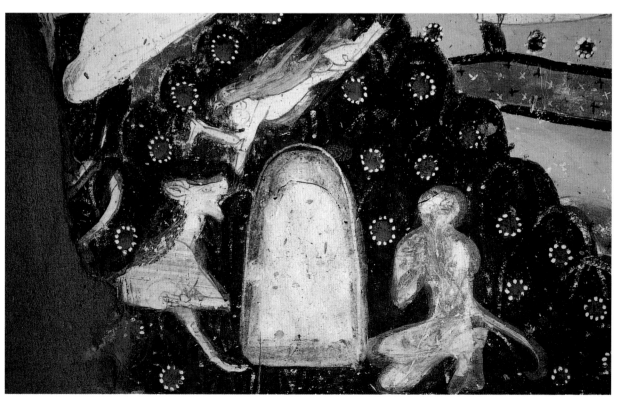

The queen's revenge

Many of the *jatakas* feature an elephant – an incarnation of the future Buddha – which comes to the aid of someone who then proves ungrateful. Among these is the famous tale of the white elephant with six tusks. In this particular cave, only the penultimate episode is depicted: the moment when the hunter is about to shoot the animal. He intends to appropriate the tusks, claimed by the wife of the king of Benares. In a former life, the queen was the consort of the white elephant, which slighted her for another companion. Humiliated, she swore vengeance in a future existence. Having fallen ill, she asked the king to obtain for her the white elephant's six tusks, which, she said, had the power to cure her. Only one hunter, who had once been spared by the elephant, knew the location of its lair, but had promised never to reveal it. However, enticed by the king's offer of a reward, he set off into the forest to capture the beast. The latter helped him in his mission, tearing out its own tusks before dying. When the spoils were brought to the palace, the queen, too, fainted and died.

[Cave 14]

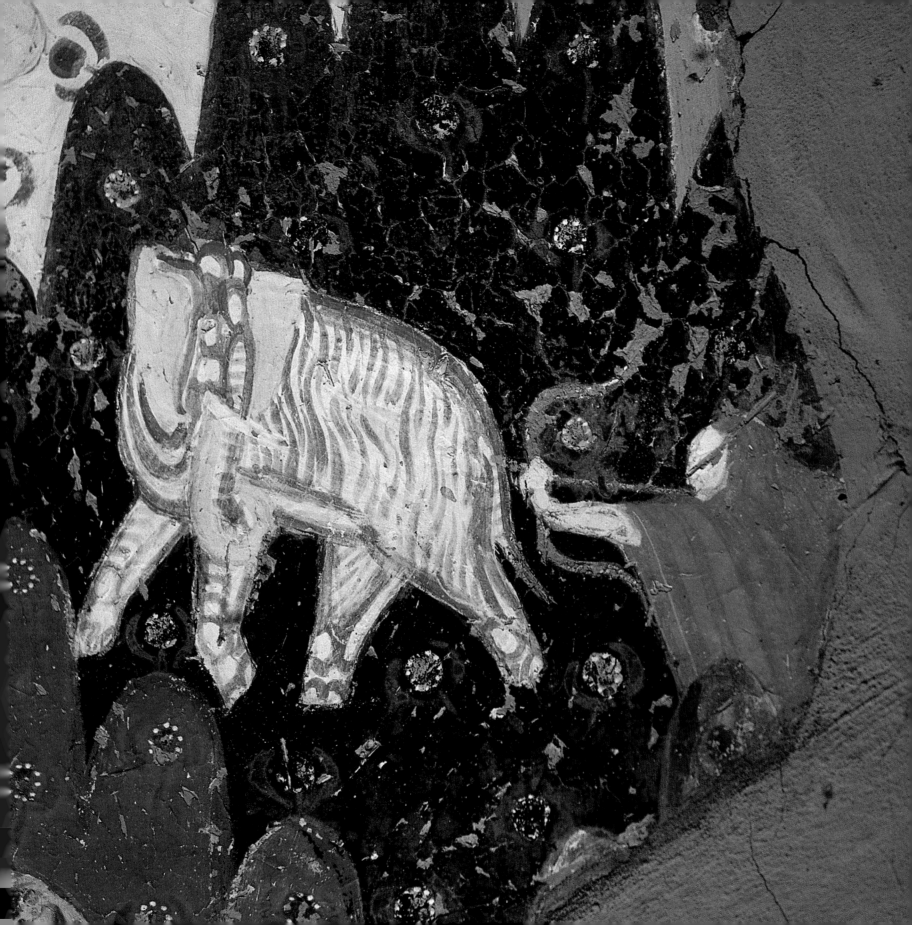

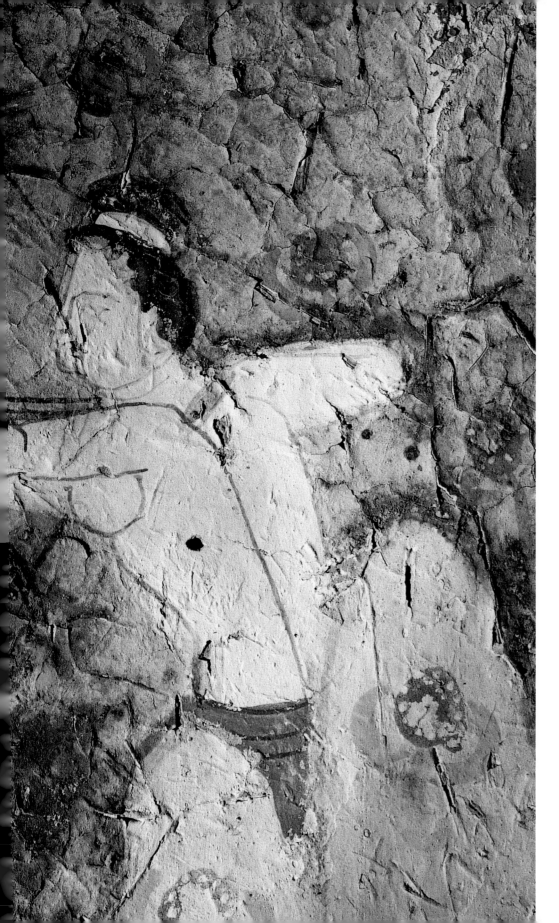

The woodcutter and the bear

This is another hunting tale on the theme of ingratitude, but here the animal that suffers is no longer an elephant. A woodcutter, saved from a falling tree by a bear, kills the animal soon afterwards in order to obtain a promised reward.

[Cave 14]

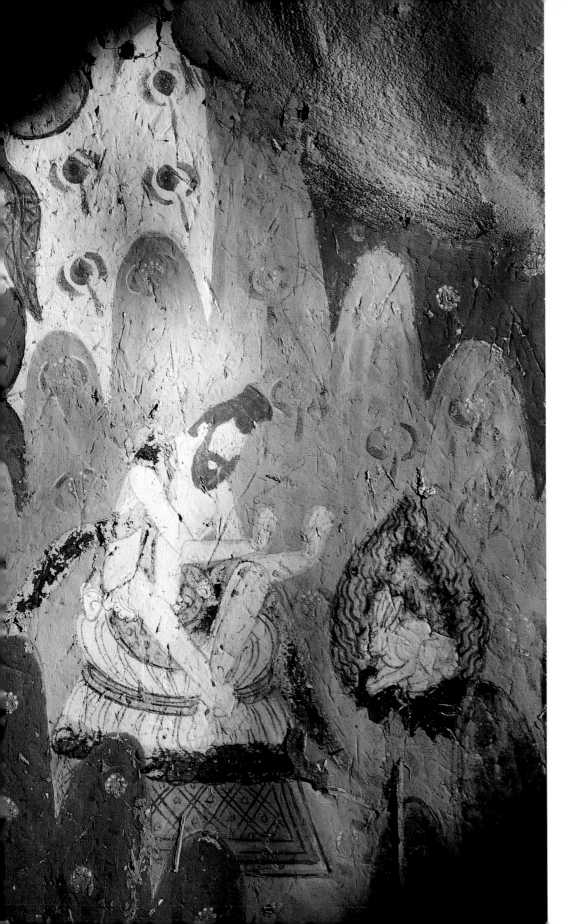

The hare's sacrifice

This is the *jataka* of the ascetic and the hare. A Brahmin who had just preached a long sermon to a gathering of animals in the mountains had nothing left to eat. He was about to depart when a monkey and a hare decided to fetch food for him. The monkey brought back some honey, but the hare lit a fire and threw himself onto it. To the Brahmin he said: 'I am only small, but my body will make you a good meal.' Here we see the Brahmin, sitting on a bamboo stool, watching the hare roast in the flames.

[Cave 14]

The ogre and the king of the monkeys

The Cave with the Bodhisattva Vault contains a scene depicting the amusing tale of a group of monkeys who got the better of a demon that lived at the bottom of a pool. This demon would catch and eat the monkeys when they came to the water to drink. The monkey king, anxious to save his subjects, looked for a way to help them avoid the ogre without dying of thirst. He told them to bring a reed each and dip the end in the edge of the pool. Like this they could suck up the water without being snatched by the demon. In this photograph we see the monster's head, with its pointed ears, emerging from the the water.

[Cave with the Bodhisattva Vault]

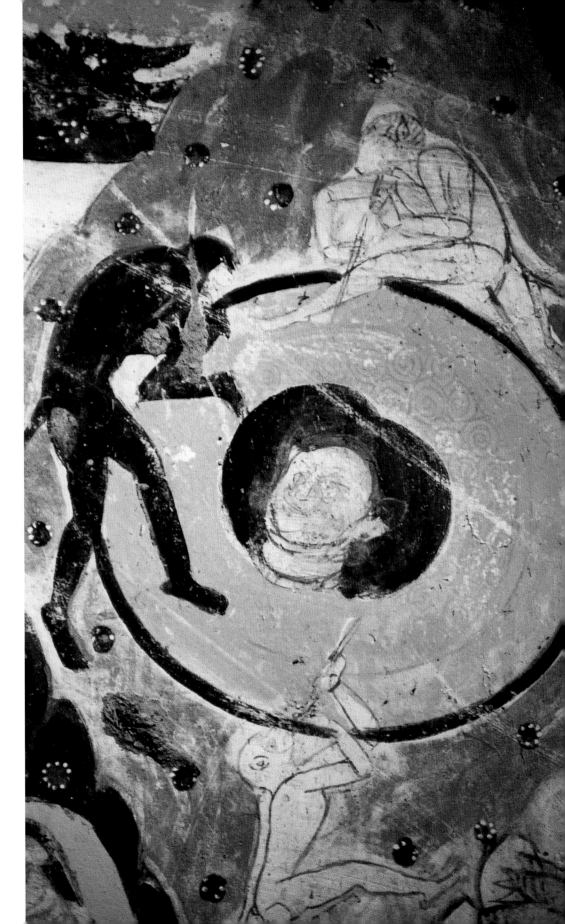

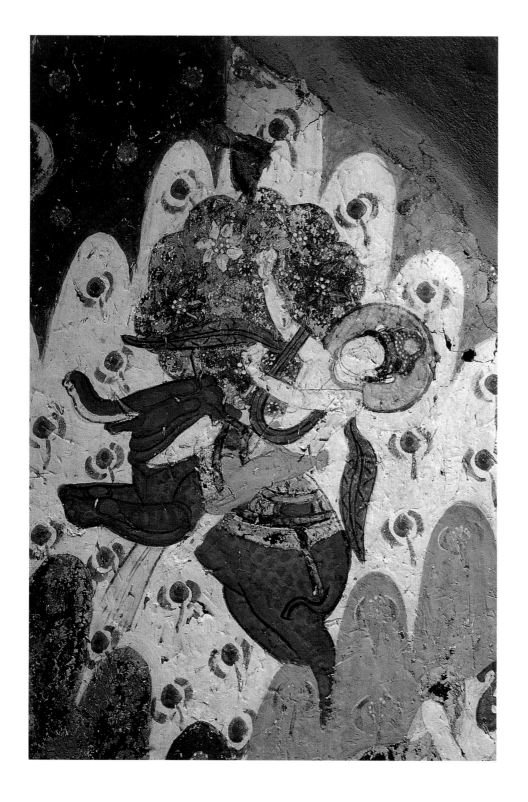

The charging elephant

An *avadana* concerning King Mahaprabhasa. While the king was chasing a wild elephant, the tame elephant he was riding went out of control and ran amok. The mahout advised the king to grab the branches of a tree. The king was furious and rebuked him, accusing him of having failed to train the animal properly. The mahout replied that he had taught it to obey, but he could not control its sudden whims: only the Buddha could master the passions.

In this scene, the king is shown clinging to the branches of the tree. The same *avadana* is found in several other caves, including the Musicians' Cave, where the elephant is white.

The hermit and the beggar

The *Sarvandadarasa jakata*.

A king bequeathed his realm to a jealous rival and went off to live as a hermit. Meditating under a tree, he was approached by a begging Brahmin. In exchange for alms, the king obtained permission to rid himself of the envious usurper.

[Cave 14]
▶ *[Musicians' Cave]*

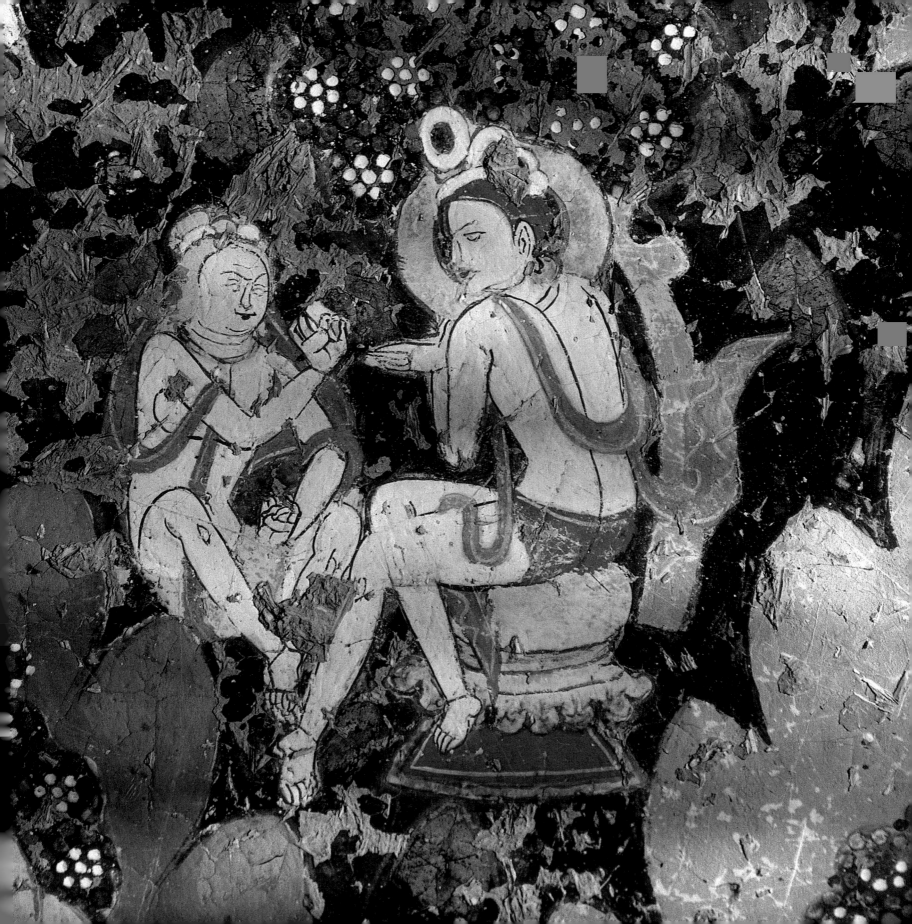

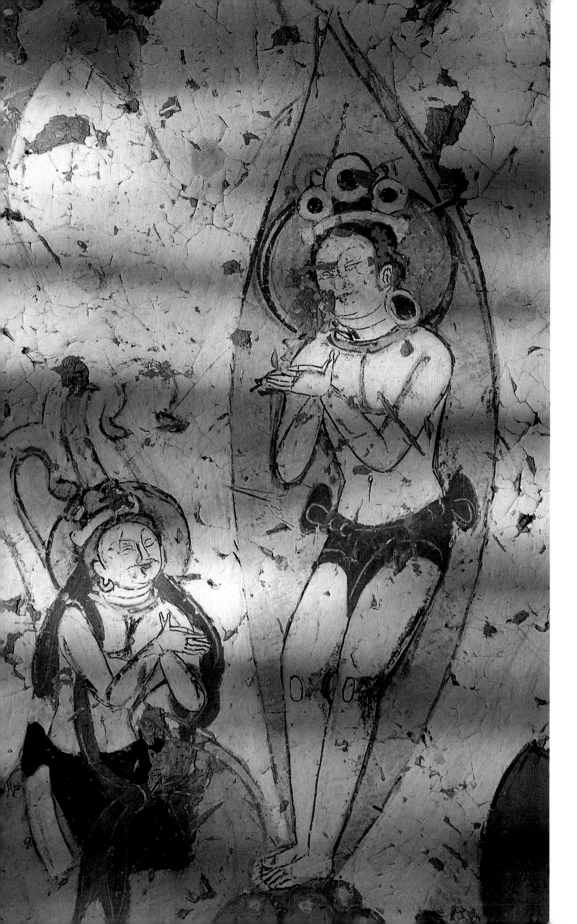

The conversion of the serpent

Here Nagaraja, the king of the serpents – recognizable by the three snake heads rearing over his human head – raises the upper part of his body from a pool in order to hear a sermon by the Buddha, who is standing on a rock.

[Musicians' Cave]

The demon and the bodhisattva

This scene depicts a discussion between a demon and a bodhisattva. The blue demon, with pointed ears, seems to be holding a bird's head in his hands. He may be the Yaksa, or spirit of the flowering tree whose branches the preacher is holding or leaning against as he inclines towards his interlocutor.

Messengers on sacred mounts

In Maya Cave III a group of monks is painted on the overhead frieze (overleaf). They are the Buddha's messengers, riding on various mounts: from left to right, wild geese, a lion, elephants, a panther. The sky is full of small flowers tossed around and kept afloat by the wind. The monks ride ahead of the Buddha, summoned by Sumati, a young girl on the eve of her wedding. Before marrying, the bride-to-be is anxious to convert her future mother- and father-in-law, who are Brahminists, to the new Doctrine.

[Musicians' Cave]
▶▶ *[Maya Cave III]*

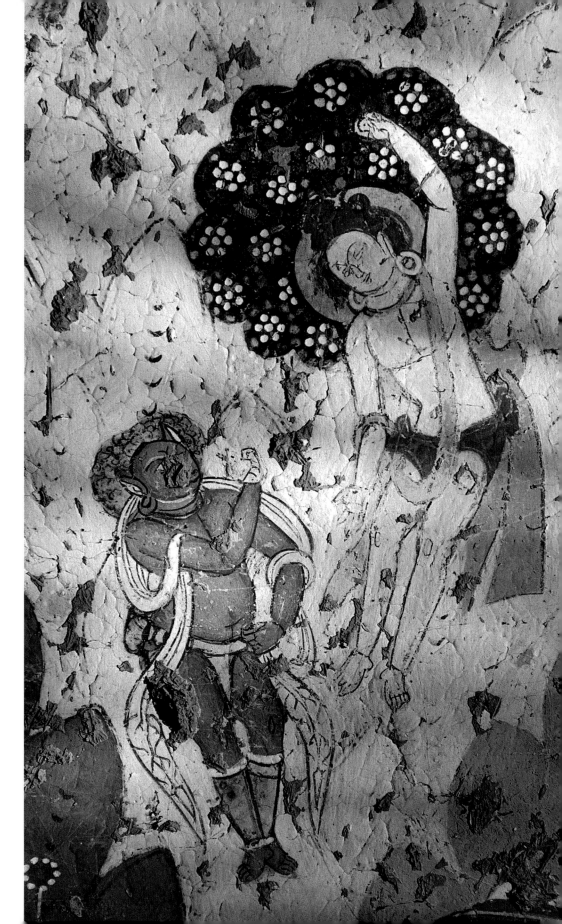

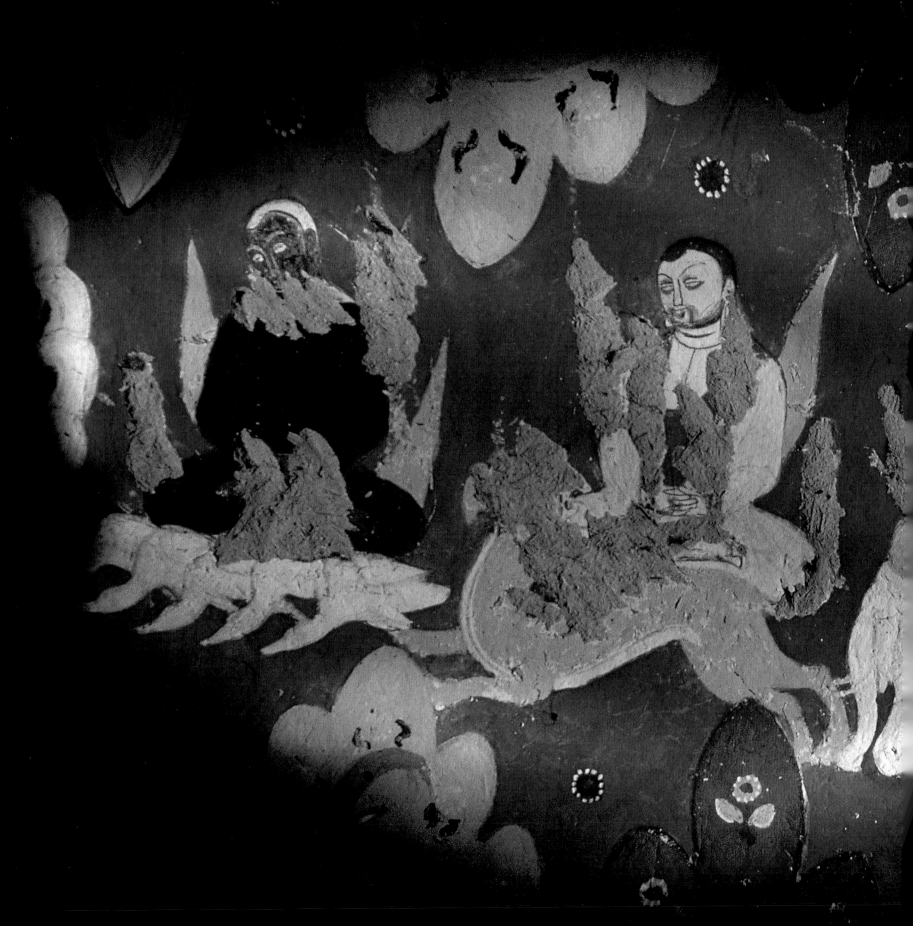

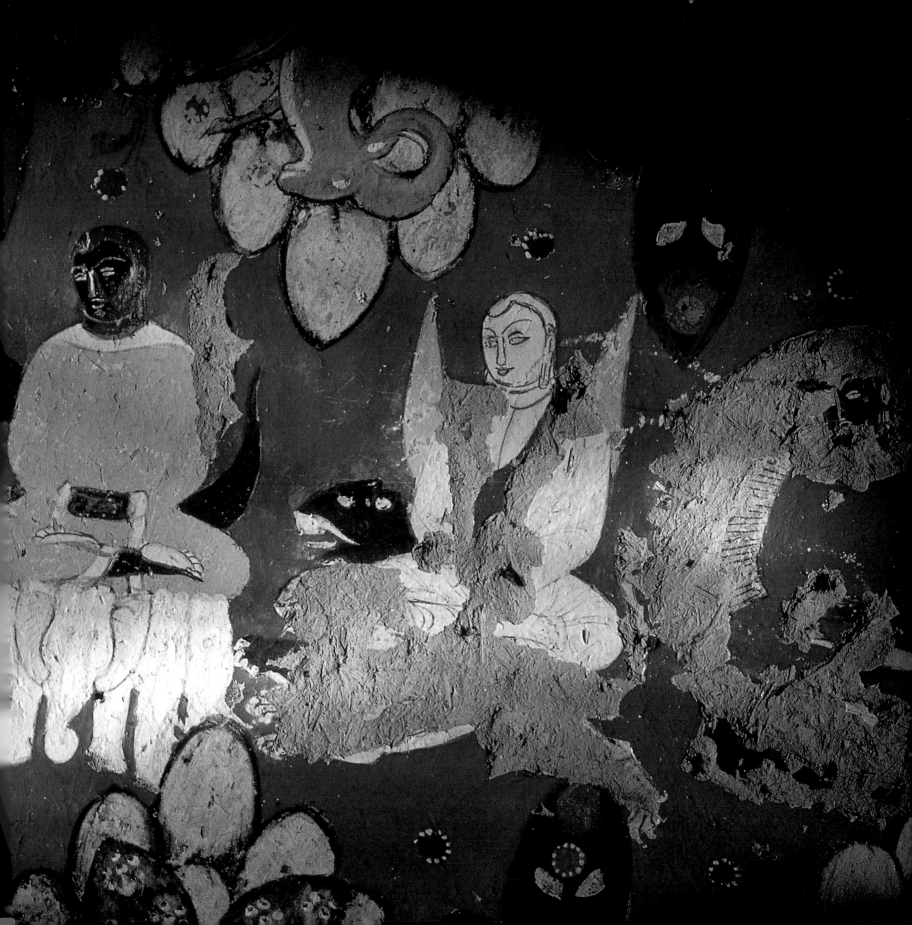

Gods and Humans

The cave paintings of Kizil and Kumtura are thronged with a whole universe of creatures both human and divine – flying divinities, demons, Brahmins, ascetics, princes, musicians, hunters and merchants. Some introduce the observer to the Buddhist pantheon, which had adopted a number of such figures from Hindu mythology; others contain clues about the composition of cosmopolitan Kuchean society. This type of evidence is invaluable for the historian seeking to reconstruct the everyday life of the vanished kingdom and forced to rely on scanty information about the dress and possessions of the peasants and the nobility.

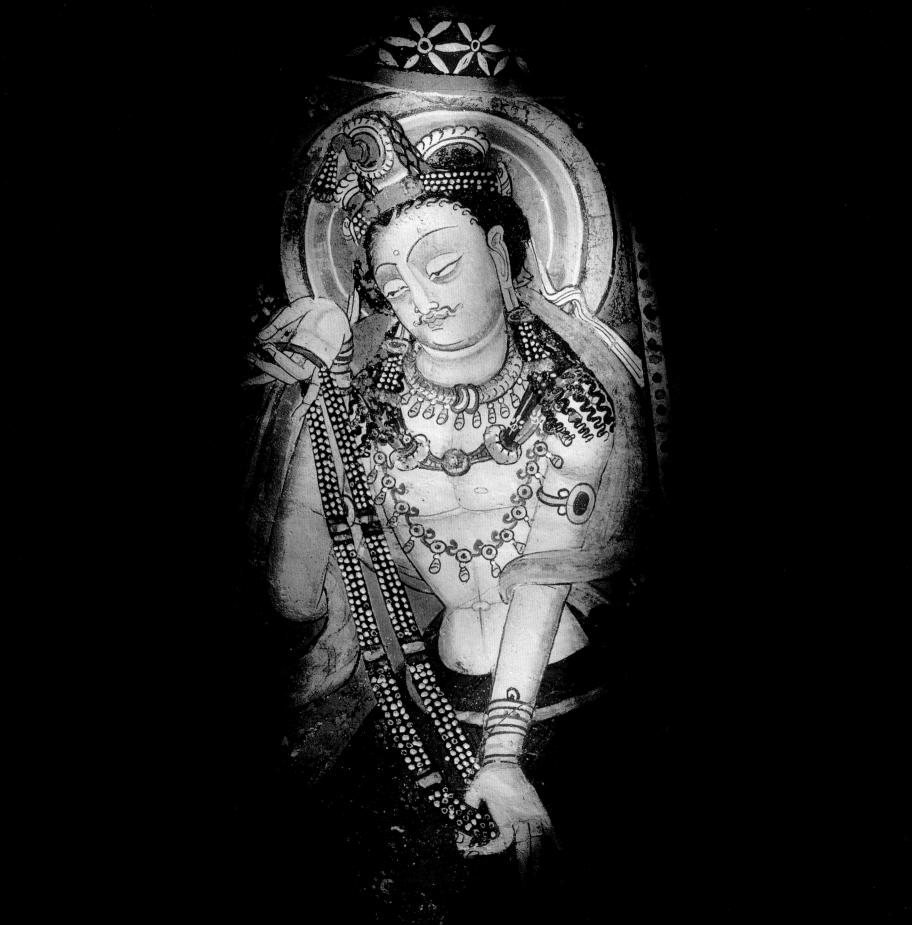

The flying nymphs

Amongst all celestial creatures, the *apsaras* – easily identified in this scene by their long legs pressed against each other (right) – are the most graceful. The immense scarves which envelop them serve to emphasize their shapes.

Below the flying *apsara*, whose movements resemble those of a free-floating astronaut, two mourning kings lean over a mandorla and contemplate the Buddha's body. One wears armour, while his head is adorned with a superb diadem with streaming ribbons that recalls the crowns of Sasanian kings. His companion is dressed in a very similar fashion.

Apsaras are the favourite companions of musicians. In Kucha they usually wear the traditional costumes and hairstyles of Indian princesses, but they may also carry bowls filled with flowers that they scatter over the Buddha as he rests in *parinirvana*: the photo on this page shows an example from the roof of a recently discovered cave at Kizil.

[Cave 1]
▶ *[Cave 1]*
◀◀ *[Chimney Cave]*

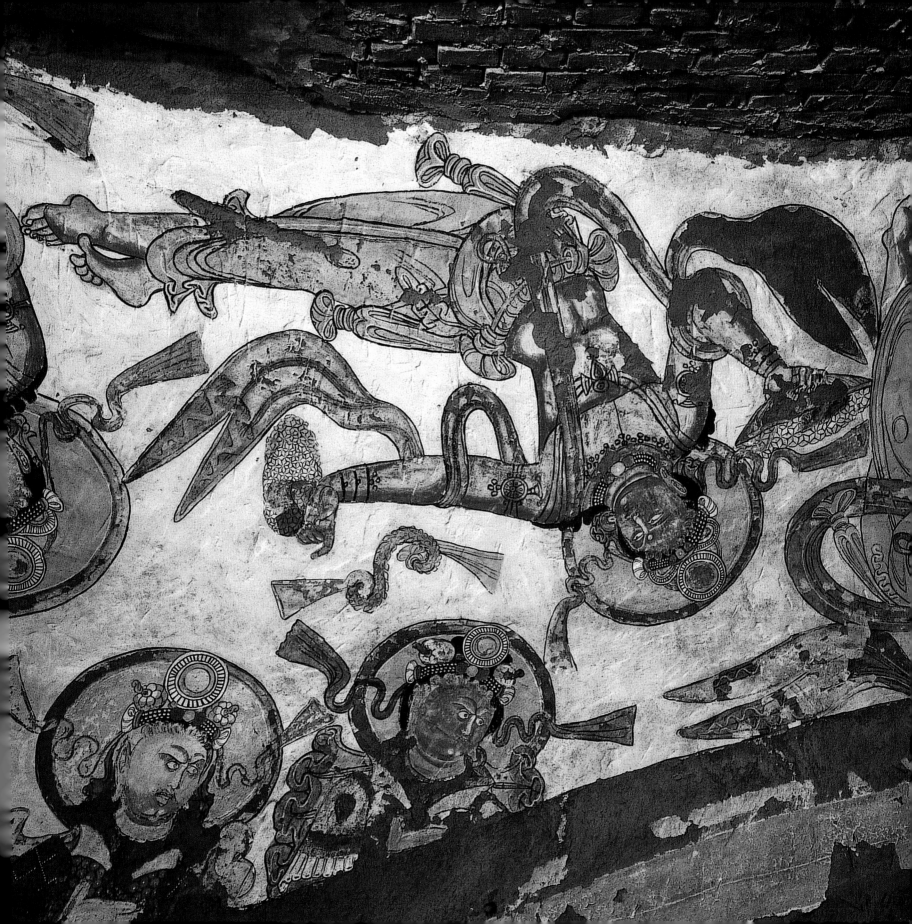

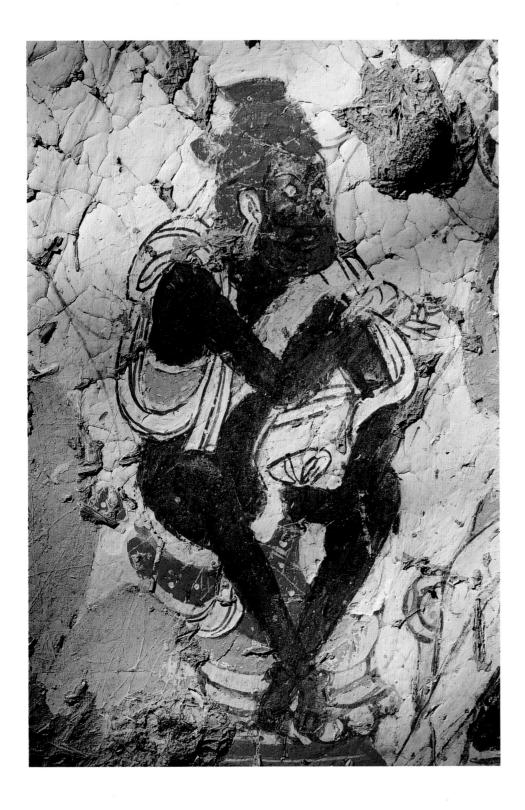

Brahmin ascetics

Ascetics, often Brahmins, are shown with very dark skin and black or blue beards and hair, as here. Their only clothing is a loincloth, apart from a matching scarf twined round the upper body. The topknot, perched on the crown of the head, consists of the full length of hair skilfully wound together, and is one of the distinguishing marks of the ascetic. Both the monk in the left-hand photo and the water-drawer on the double-page overleaf have topknots. Images of naked ascetics are also found, like this devotee (right) offering honey to the Buddha and bending low in a magnificent gesture of humility.

[Musicians' Cave]
▶ [Maya Cave III]
▶▶ [Cave 14]

112

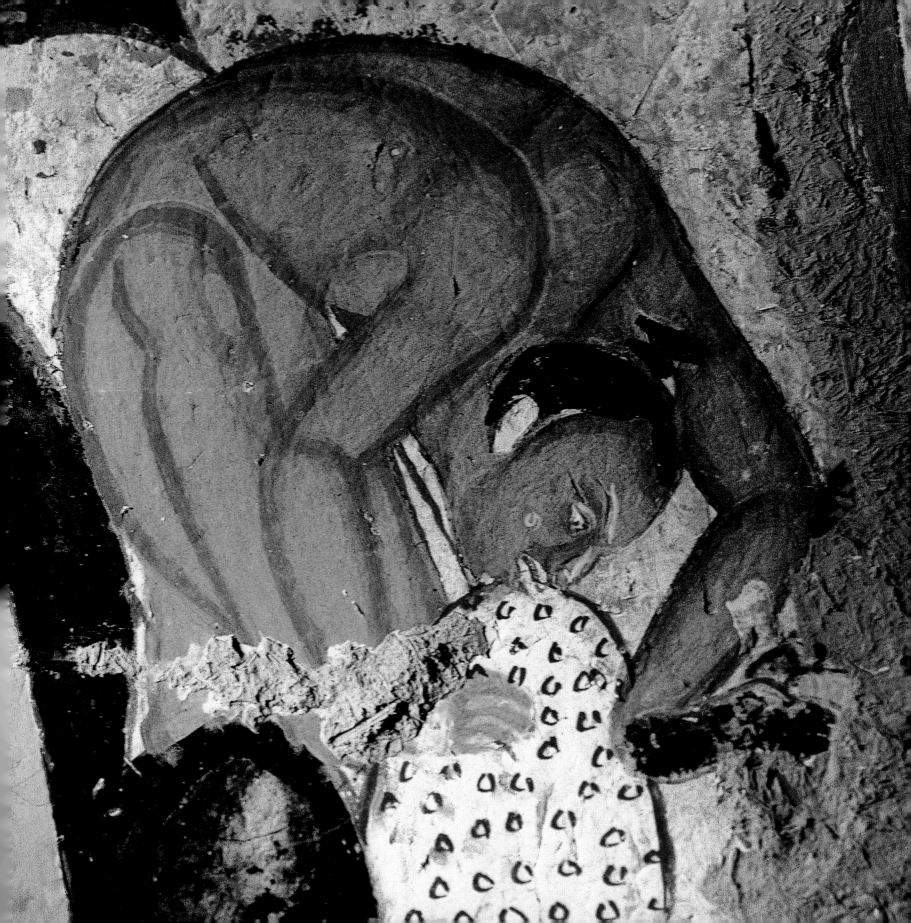

The leaping Brahmin

This extraordinary image illustrates the dynamism of Buddhist influence. It shows the precipitous arrival of a character in Indian costume, perhaps a Brahmin, whose movements are depicted with amazing fluidity. He plunges towards a donor-creature – probably the king of the serpents – emerging from the water and offering up a diadem. The convergence of the two figures, one in motion through the air, the other through the water, reveals the skill of the Kuchean monks in using every artistic resource to convey a sense of three-dimensionality.

[Musicians' Cave]

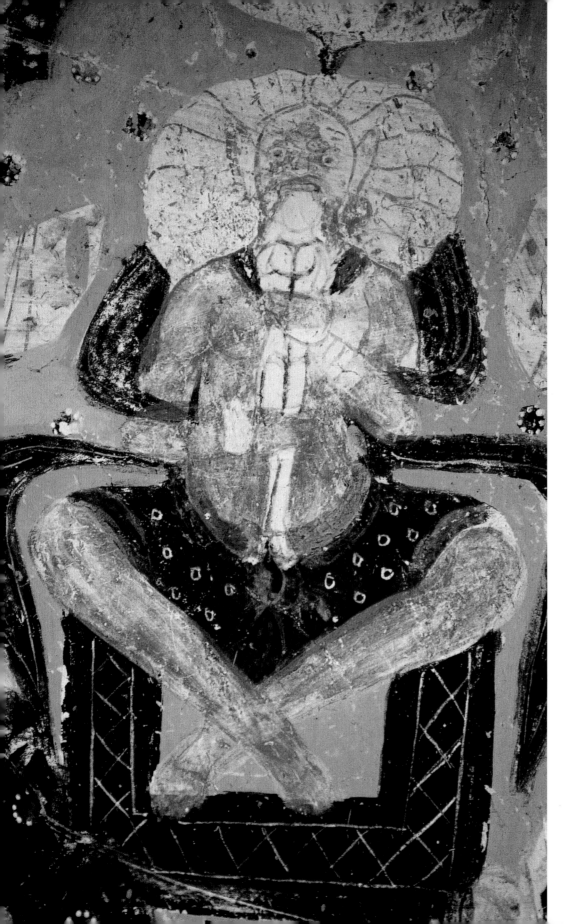

The conversion of the ogress

The spectacular, demonic figure here seated on a throne with her ankles crossed is an ogress. She is about to devour a child. This terrifying creature has the attributes of Hariti: pointed ears, bulging eyes, masses of hair. Her blue skin makes her even more outlandish.

Hariti was an ogress who ravaged the district, snatching children and eating them. Tearful mothers begged the Buddha to put a stop to her savagery. In order to make her understand the horror of her actions, the Buddha hid her son, whom she loved tenderly, and refused to return him until she promised not to devour other people's offspring. She kept her promise, and even became the guardian of young children.

[Cave with the Bodhisattva Vault]

Fauns in the service of the Buddha

The Yaksa, led by Kubera Vaiszavana, are very ancient Indian divinities of vegetation, particularly trees, and fertility. In Central Asia, they are represented with pointed ears and sharp teeth. In the shrines along the Silk Road, they became ardent defenders of the Buddhist teaching. Here we see one of them, his hands joined in *anjali*, listening in rapt attention to the words of the Buddha.

[Musicians' Cave]

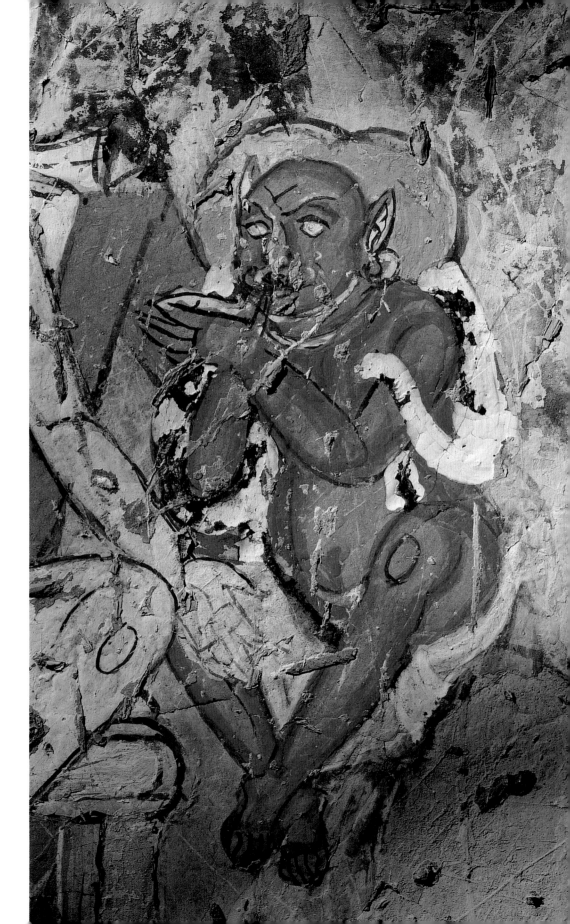

The knight-princes of the kingdom of Kucha

The princely figures shown in the caves include members of the Kuchean nobility, like this kneeling man wearing local dress. He raises his hands towards the Buddha, to whom he has no doubt offered the blue bowl seen to the right. His long, tightly fastened coat has lapels made of a dark material, with matching cuffs; it is held in place by a sword-belt. The German archaeologist Grünwedel expressed his astonishment on discovering 'the red hair, the fair skin and blue eyes of the knights depicted as donors on the passage walls'. This man has brown hair, but the bandeau around his topknot is similar to that worn by princes.

[Musicians' Cave]

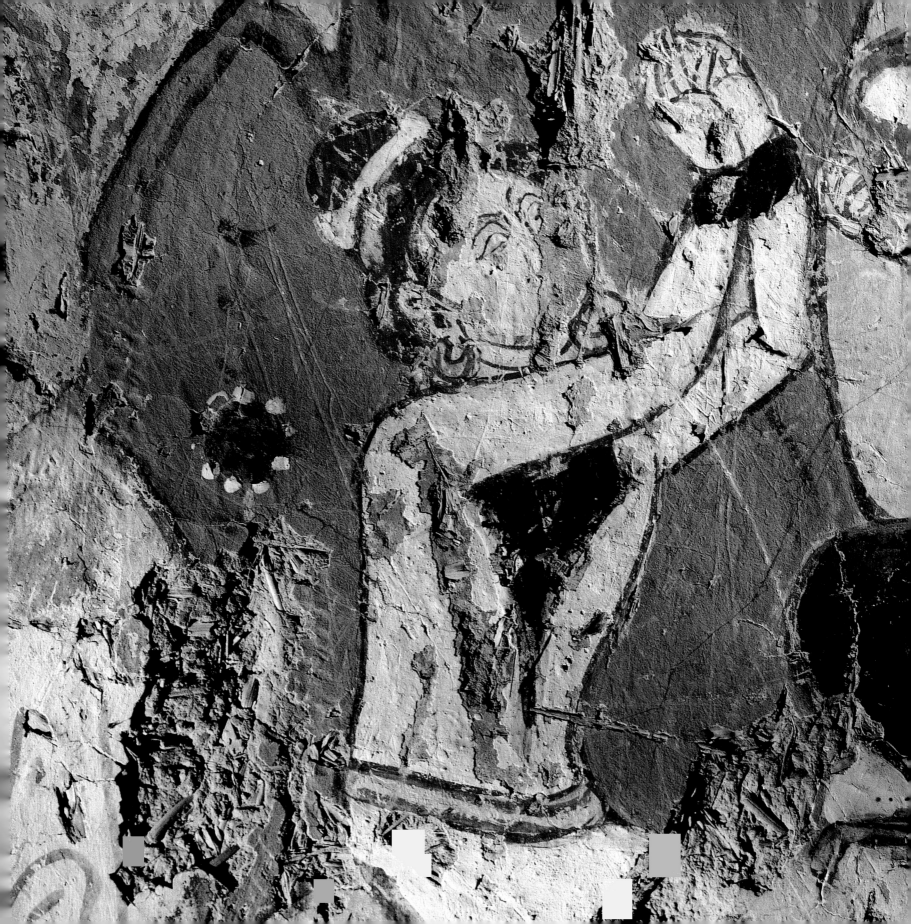

Merchants and huntsmen in local costume

Two men stand in a curious boat with dragon prow and stern. They are wearing the typical male Kuchean costume of embroidered tunic and wide trousers tucked into boots. They are merchants: their boat is sinking and they are about to dive into the water. One wears a round white hat with a padded band. Several *avadanas* among the Kizil paintings illustrate sea journeys, like this *Maitrakanyaka avadana*. The hunter (right-hand page) and the red-headed riders (overleaf) are dressed in the same style.

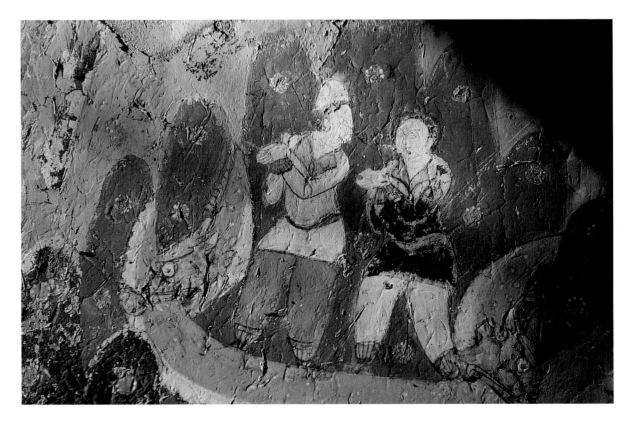

[Cave 14]
▶ *[Cave with the Bodhisattva Vault]*
▶▶ *[Cave 14]*

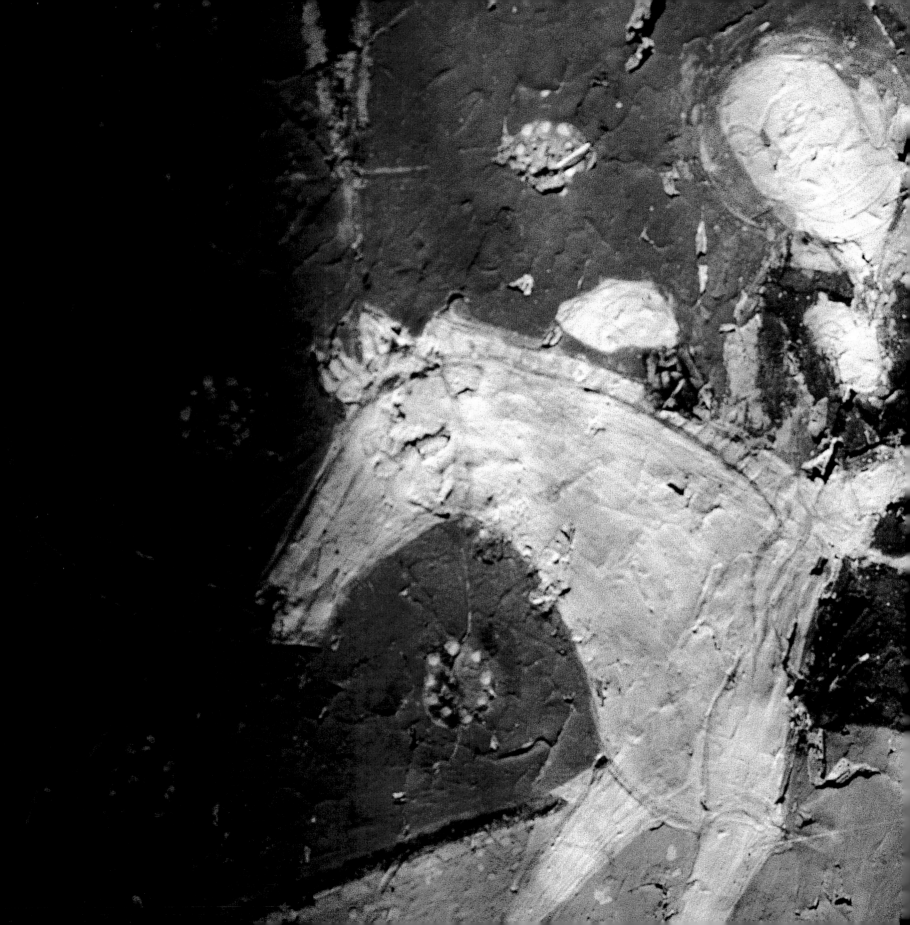

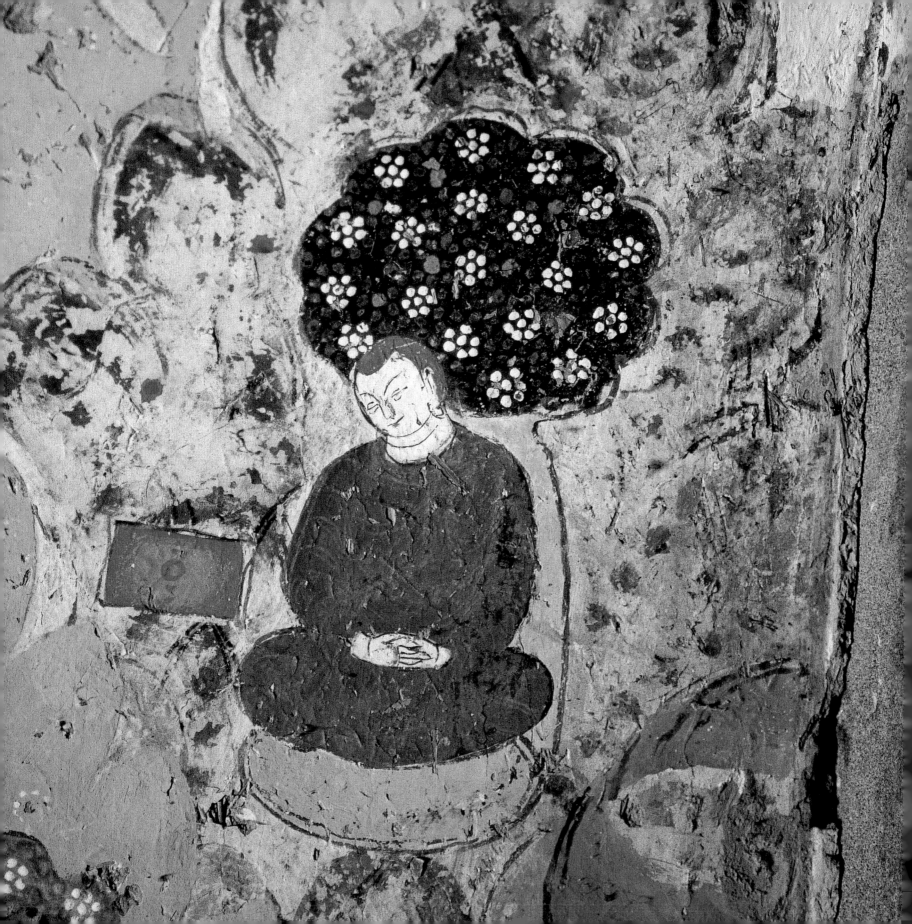

The monks dressed in patchwork

With shaven heads and both shoulders covered, this monk shown meditating near a small pool is typical of countless others found in the cave paintings. In another example (Maya Cave III), Kasyapa, the first monk to prostrate himself at the feet of the Buddha in *parinirvana*, wears the traditional garment made in the way recommended by the Enlightened One: pieces of fabric scavenged from cemeteries and rubbish heaps were washed and then assembled to form a large rectangular piece of cloth. The monks wore this over a sort of underskirt also made of rags. From the time of the earliest Buddhist communities, the monk's only work was fashioning and caring for his robes, since he obtained his food by begging. The patchwork robe is another recurring theme in the rock paintings at Kizil.

[Maya Cave III]
◀ *[Musicians' Cave]*

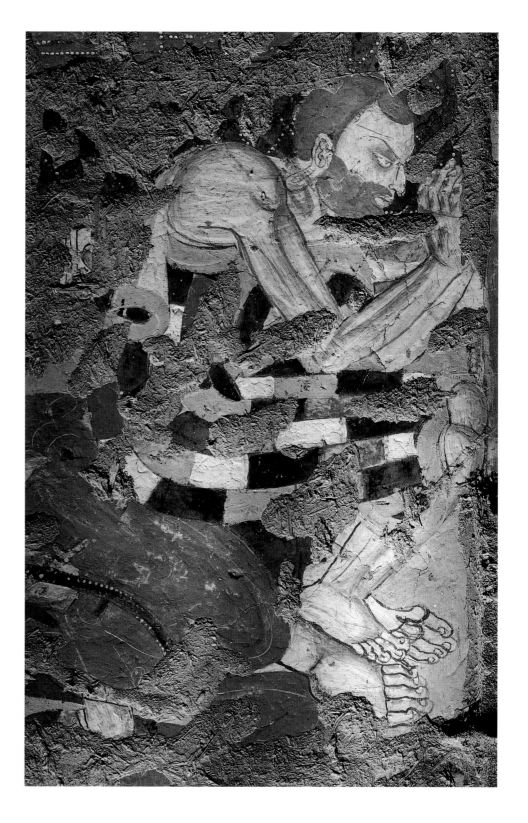

127

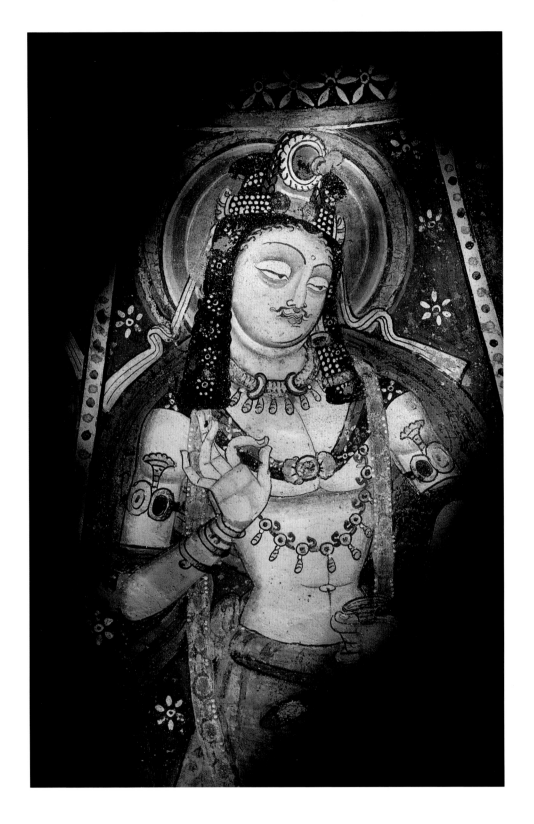

The Cupola of the Thirteen Bodhisattvas

The painted vault of this recently discovered cave at Kumtura depicts a group of bodhisattvas arranged in a kind of star-shape around a central lotus representing the Buddha. A bodhisattva is a being ready for Enlightenment, but who accepts to undergo rebirth as long as there remain men to be saved. The bodhisattvas are represented as Indian princes wearing a *dhoti* (sort of skirt) tied at the waist, a broad scarf leaving the torso half uncovered, an elaborate diadem and large earrings. Necklaces and bracelets complete their sumptuous jewellery. Their posture is somewhat effeminate, though the faces sport elegant moustaches.

The cupola is divided into compartments containing the bodhisattvas. Only one looks straight ahead; the rest face each other in pairs. The figures are distinguished by different attributes. On the double page overleaf, from left to right, the first bodhisattva sets in motion the Wheel of the Doctrine with a *mudra* gesture; the second wears a triple necklace; the third, probably Maitreya, the Buddha of the Future, carries a vase; the fourth, with a lotus, is Padmapani.

[Chimney Cave]

128

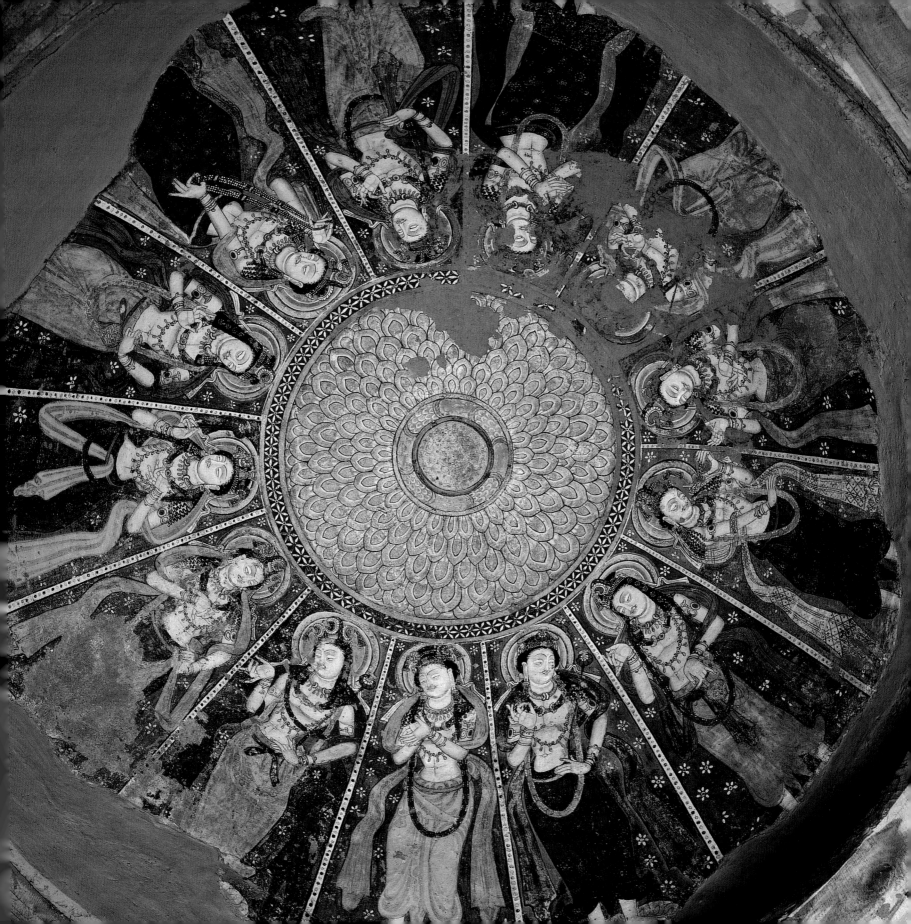

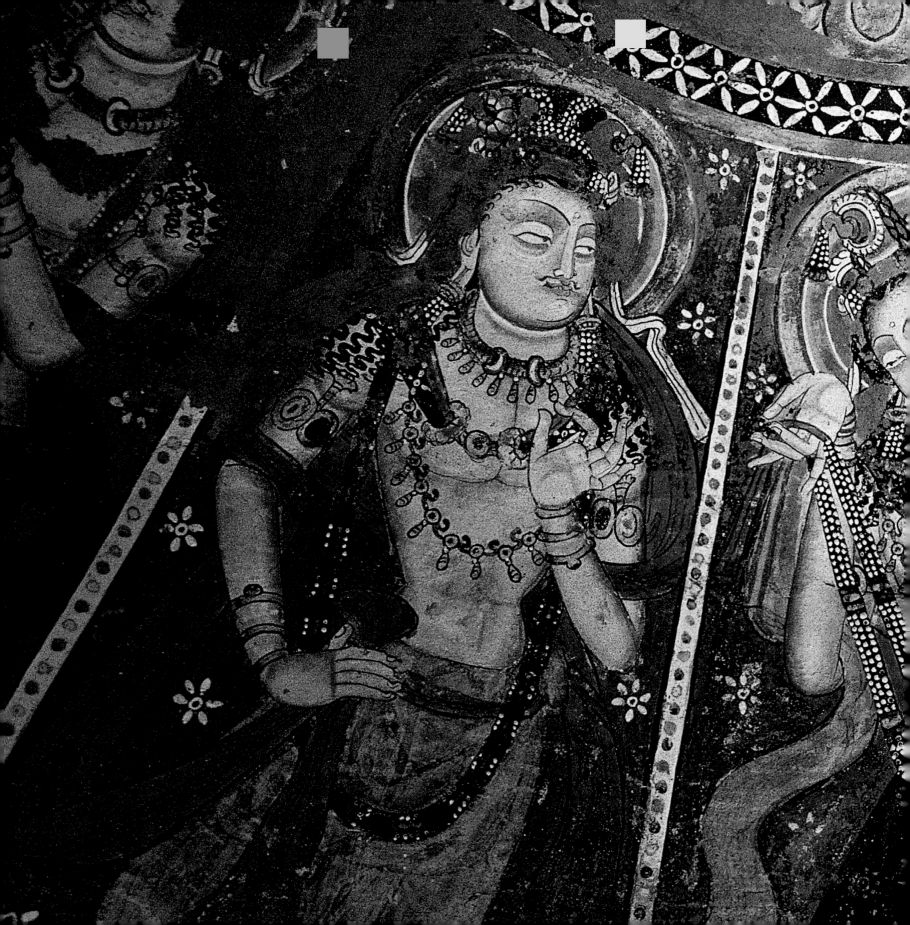

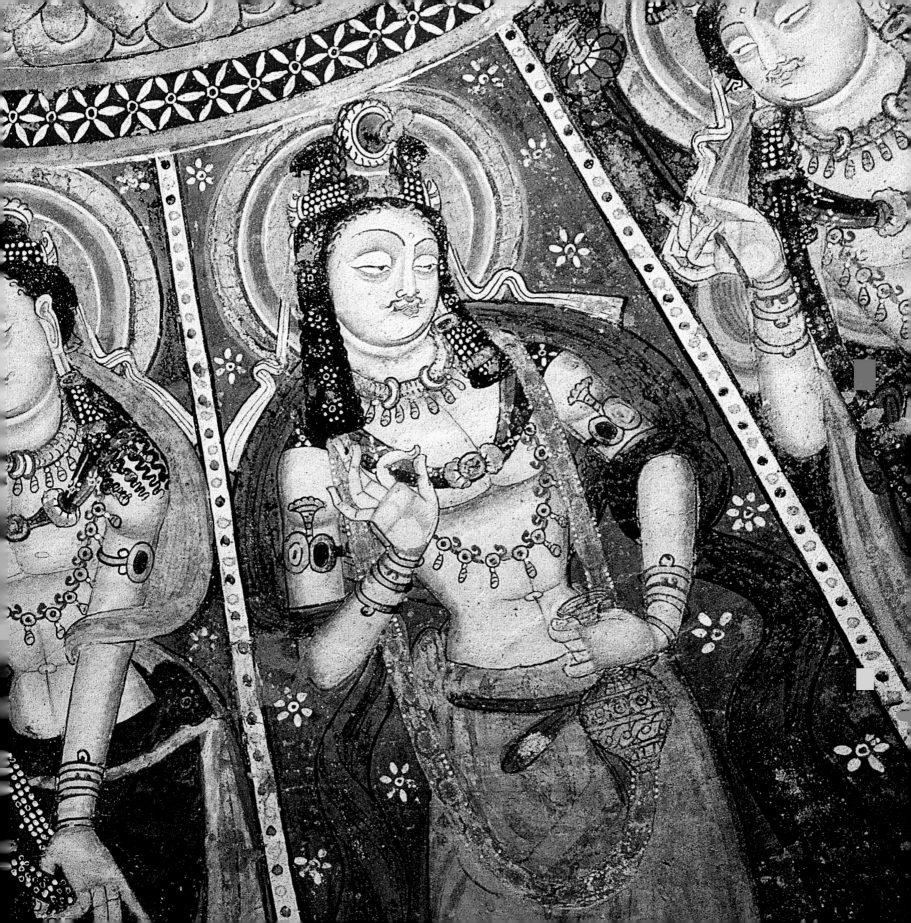

Animals

In India, the interior decoration of temples is a symbolic representation of the universe. Particularly striking is the considerable space allotted to animals. In Central Asia, too, animals play a major role, especially on ceilings covered with scenes from the Buddha's past lives. The legends are brought to life by the direct observation of local creatures and exotic species which were transported along the Silk Road to the Chinese court. Even allowing for the use of pounces, the cave painters included artists capable of catching the movements of deer and birds, and their use of colour often conjures up a heavenly oasis.

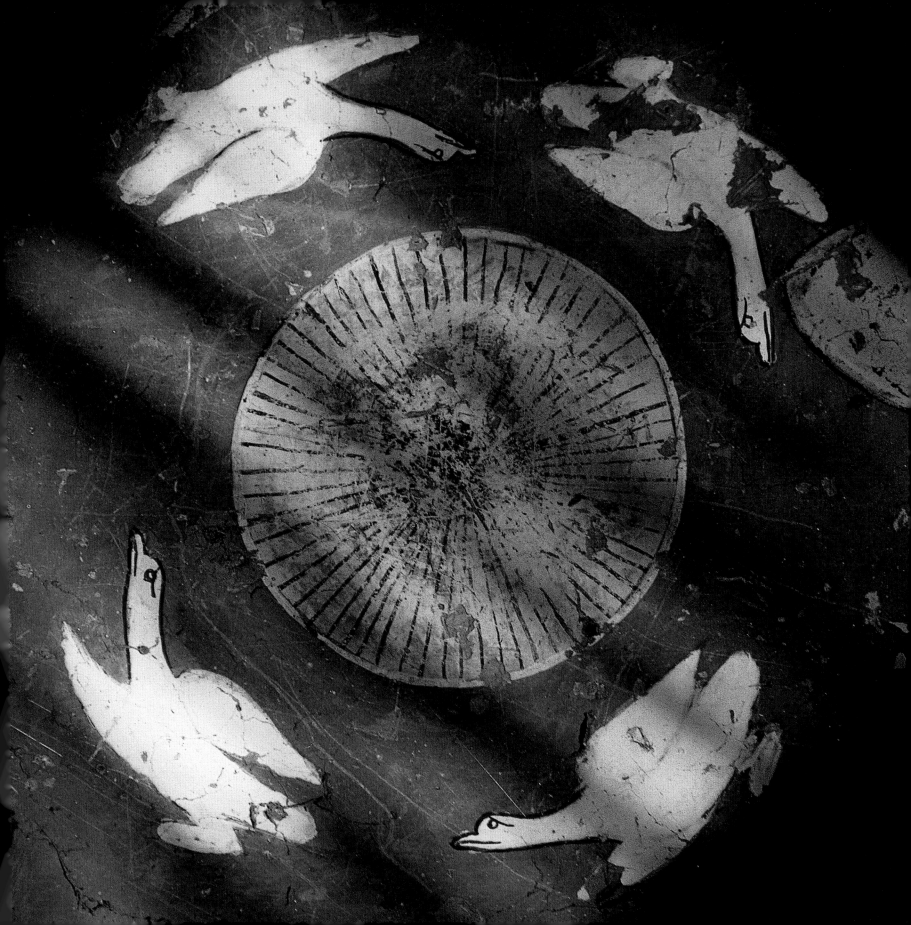

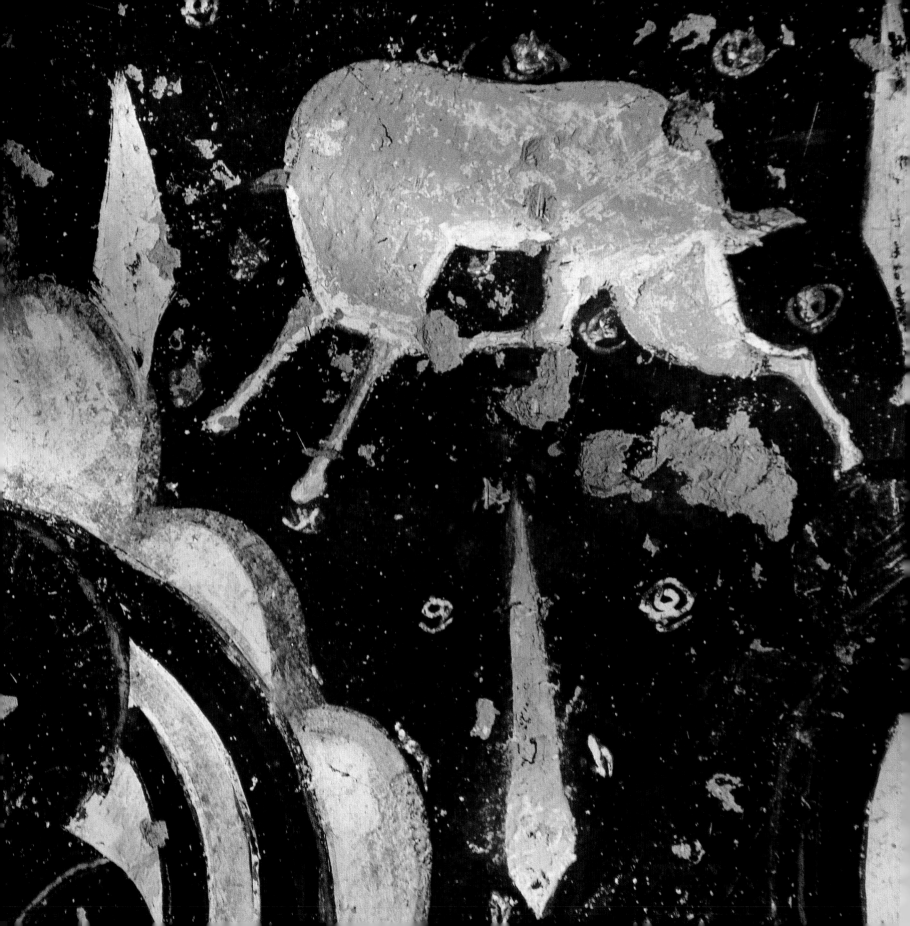

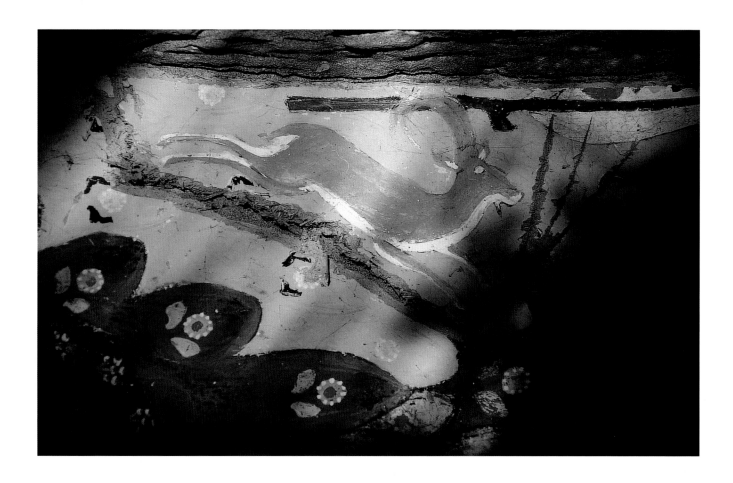

Animal Paradises

Everywhere on the cave walls are stylized mountains – overlapping lozenges in white, blue, green or brown. Flowering trees provide shade in the preaching scenes, but what really catches the eye is the animal life reminiscent of the Garden of Eden. We see bounding hinds with their fawns, wild sheep scrambling up cliffs, birds perched above the heads of ascetics and monks, while bears snooze in their caves and hares run up to hear the Buddha's teaching. Although they are wild creatures, they seem to have become tame under the Buddha's influence. Some of these animals are protagonists in the legends which inspired the paintings; others seem to be there simply to enliven conventional landscapes with their grace and energy.

[Maya Cave III]
◀ *[Cave 49]*
▶▶ *[Cave 49]*
◀◀ *[Musicians' Cave]*

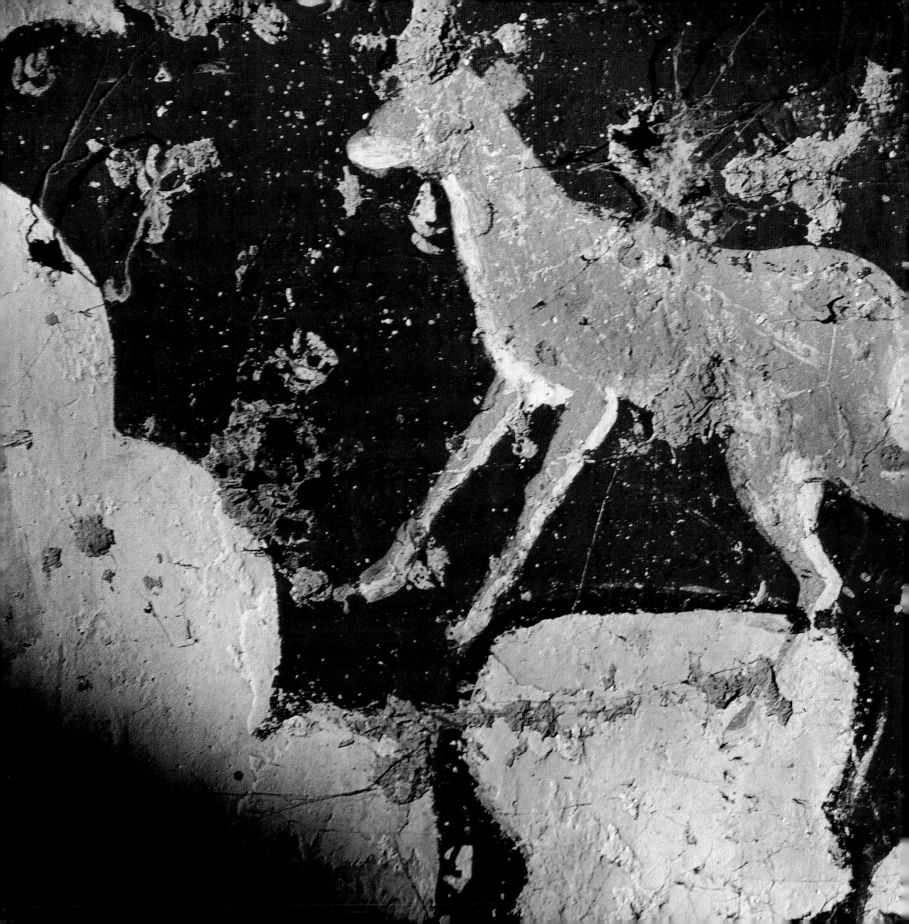

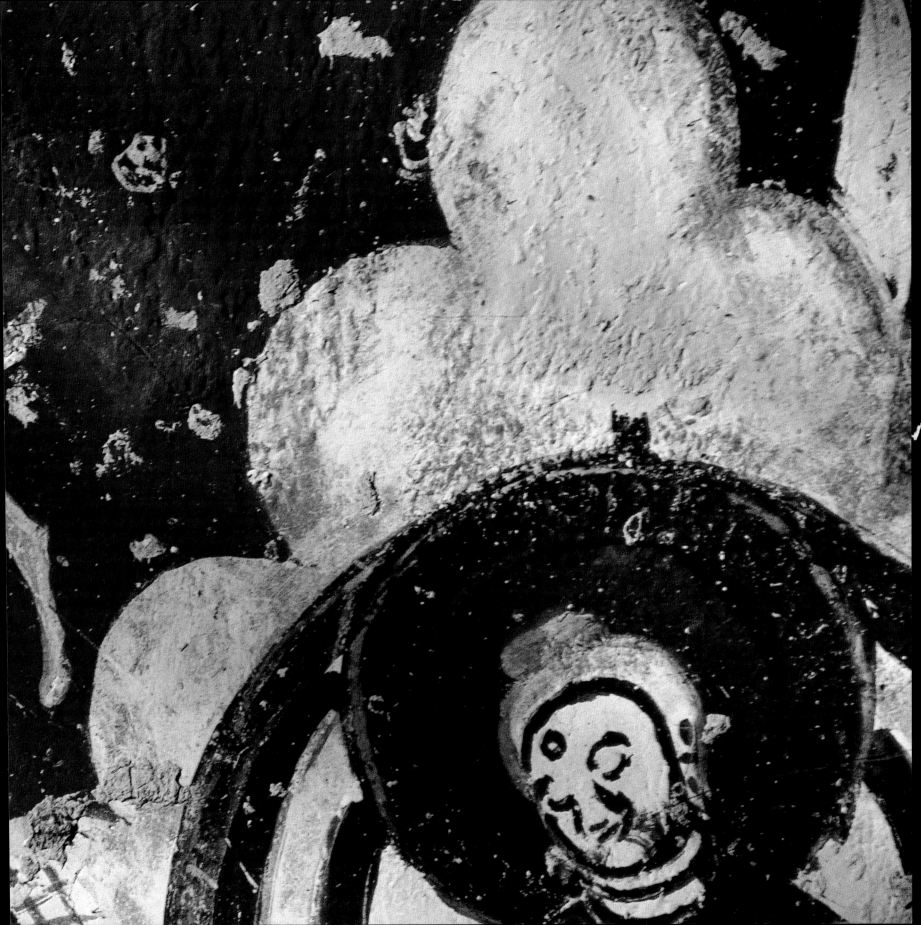

The ibex frieze

On either side of the overhead frieze in Maya Cave III are six scenes that feature ibexes. Their blue silhouettes are sharply outlined against a landscape of white and green lozenges. No doubt they were modelled on the large, bluish bharal with its curiously twisted horns, discovered between Baltistan and Kunlun at an altitude of 3,000 m (c. 10,000 ft) by the sinologist Edward Schaefer. The blue-grey colour of its coat enables the the animal to merge into the background while climbing the rock-face.

In a scene full of tenderness and grace (above), a female painted in a brilliant light blue colour nuzzles its fawn, which is learning to suckle.

 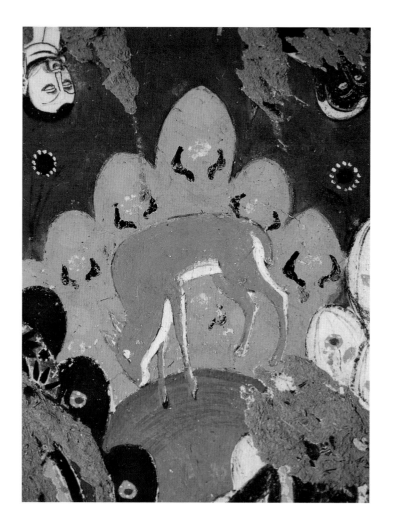

The ibex series continues on the other side of the central overhead frieze. One animal is drinking from a pool (above, right), while another leaps skyward. Other scenes show a female browsing and another leaving her lair.

The ibex and the horse are thought to have been linked in funeral rites practised by tribes of the Altai mountains: horses were fitted with mock horns made of wood and then sacrificed. This may have been the inspiration for paintings of hybrid creatures – horse-like creatures with horns.

[Maya Cave III]

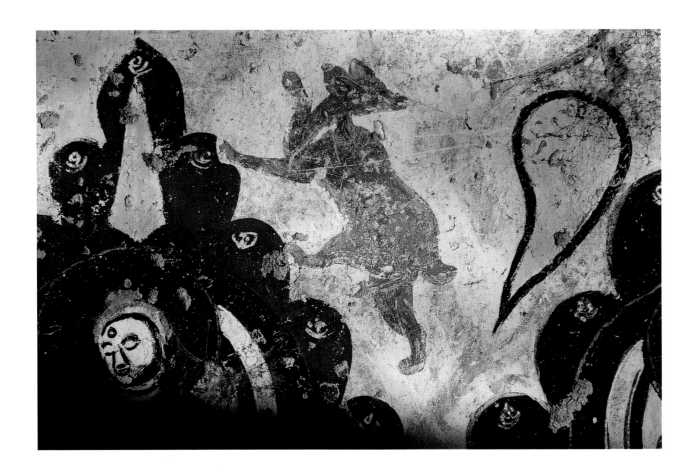

The terrified bear

The brown bear also has a place in these animal pictures. Its ferocious nature earned it the reputation of 'lion-eater'. There has been much dispute among zoologists as to what natural barriers in Central Asia might separate two species of bear: the brown bear, known also in Europe, and the black 'collared' or Asiatic bear, found only in forested regions. The brown bear, *Ursus arctos*, weighs on average 230 kg (c. 500 lb).

[Cave 49]
▶ *[Cave of the Pot of Hell]*

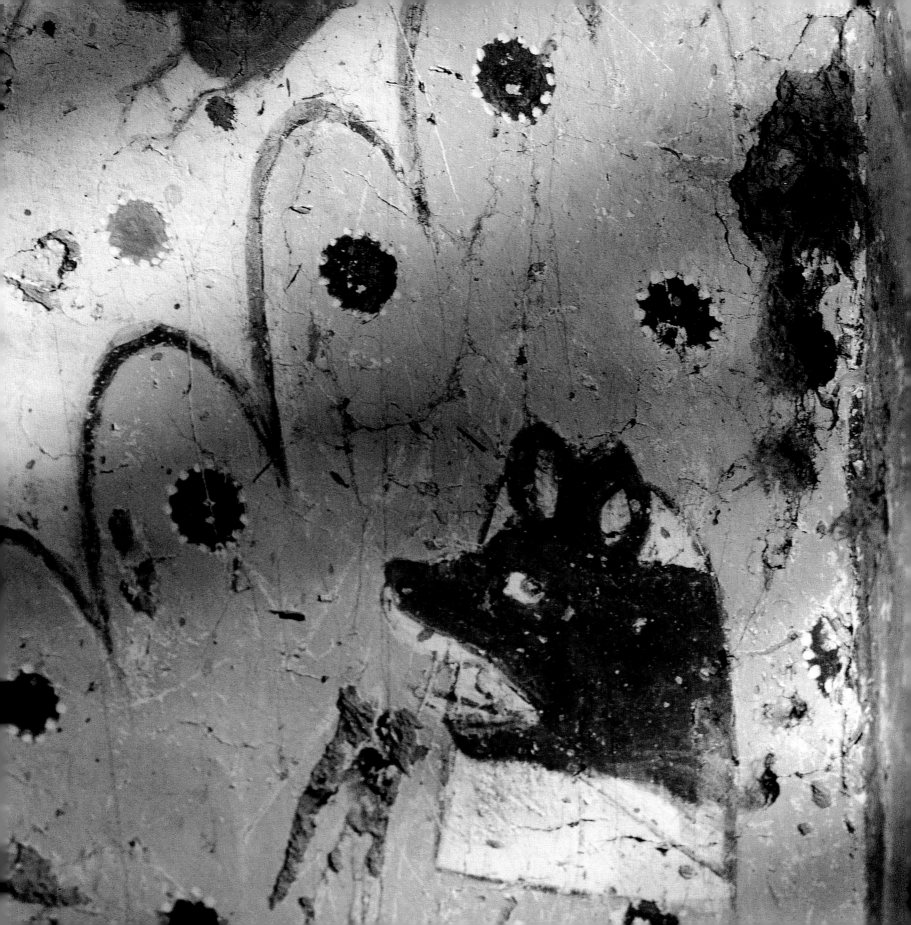

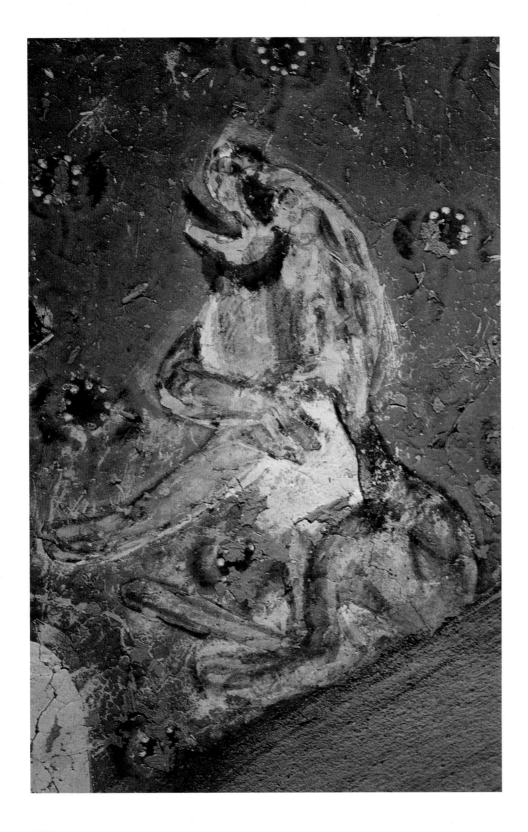

The emblematic lion

The lion is an emblematic beast in Buddhist culture. In China, it represents India itself. Its roar is a symbol (*lakshana*) of the Buddha instructing all the creatures of the universe. The Tokharians (who populated the Kuchean area in various phases of Central Asian history) are known to have sent lions to the court of the Tang in 719, 'on behalf of Rome', evidently meaning the Byzantine empire.

The lion crouching in his den (right) looks quite strange; clearly, painters at the Chinese Imperial Court conceived of the animal in a way unfamiliar to the people of Kizil. The other example (left) is much more realistic.

[Cave 14]
▸ *[Maya Cave III]*

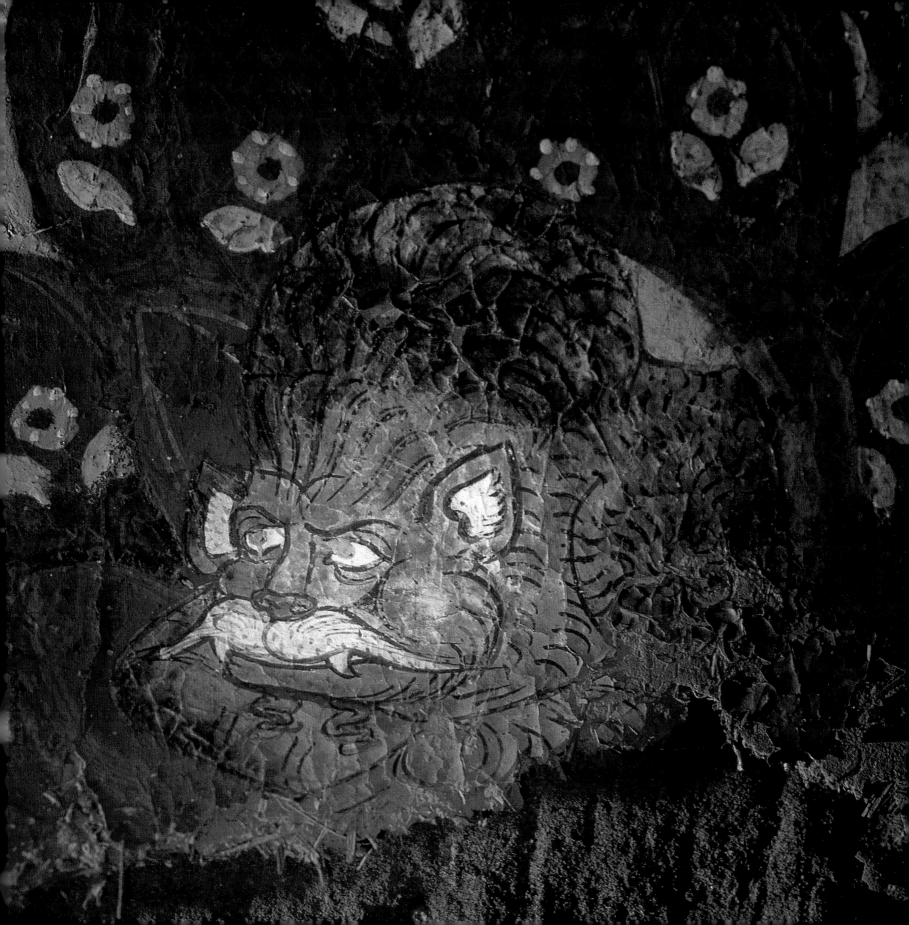

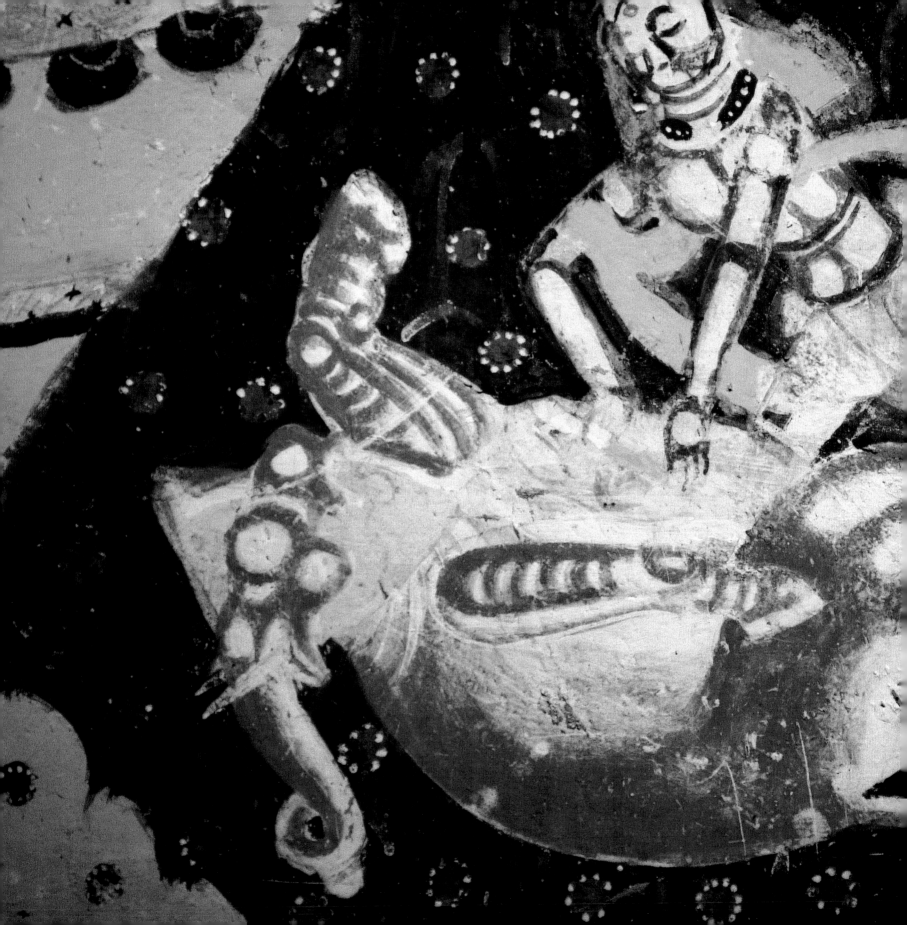

An incarnation of the elephant

Known in China since the Bronze Age, the elephant had almost died out there in the first centuries AD, except in the extreme south. Very common in India and South-East Asia, it plays a part in many *jatakas* and Buddhist legends. Maya, mother of the future Buddha, dreamt that an elephant had entered her womb. Then, when very young, Prince Siddhartha distinguished himself in an elephant hunt. Later, after his Enlightenment, when an enraged beast was about to charge and trample him, he raised his hand in a symbolic gesture, prompting the elephant to lie down in front of him. The Buddha was therefore born under the sign of the elephant. Following this tradition, elephants are depicted in the Kizil caves, but the artists have made little attempt at realism.

[Cave with the Bodhisattva Vault]

145

The wolf at the gates
of Beijing

The identity of the creature bounding across
the mountains in this scene is uncertain. It
could certainly be a wolf – but perhaps also
a hunting-dog. Kuchean scent-hounds were
renowned as far away as Beijing, and the
Emperor is known to have received several
in 721. They were found in the remote areas
of the Altai foothills. It has been suggested
that they might have been a subspecies
of Siberian wolf, but there is no evidence
for this.

[Maya Cave III]

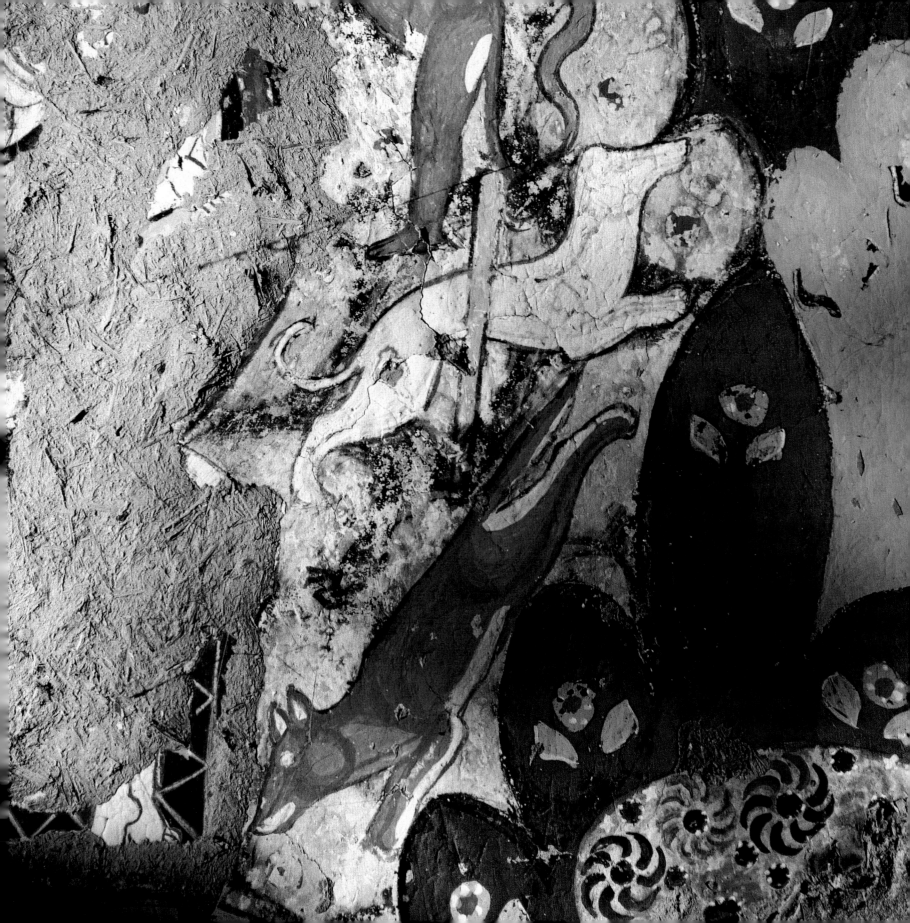

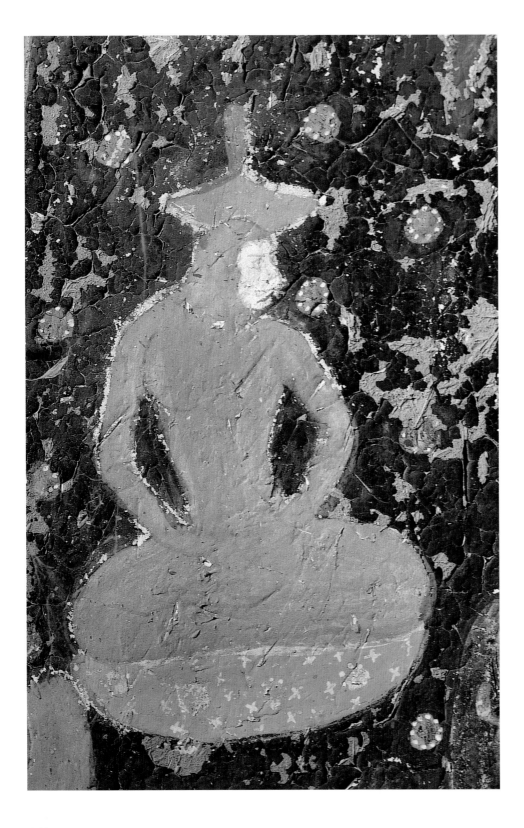

In the kingdom of the monkeys

The painted landscapes are full of monkeys, often shown in humorous postures. Their fur is occasionally coloured blue, but most often brown. These are macaques, with somewhat stiff heads and long tails – favourite characters in the *jatakas*.

[Cave 14]
▶ *[Cave of the Pot of Hell]*

148

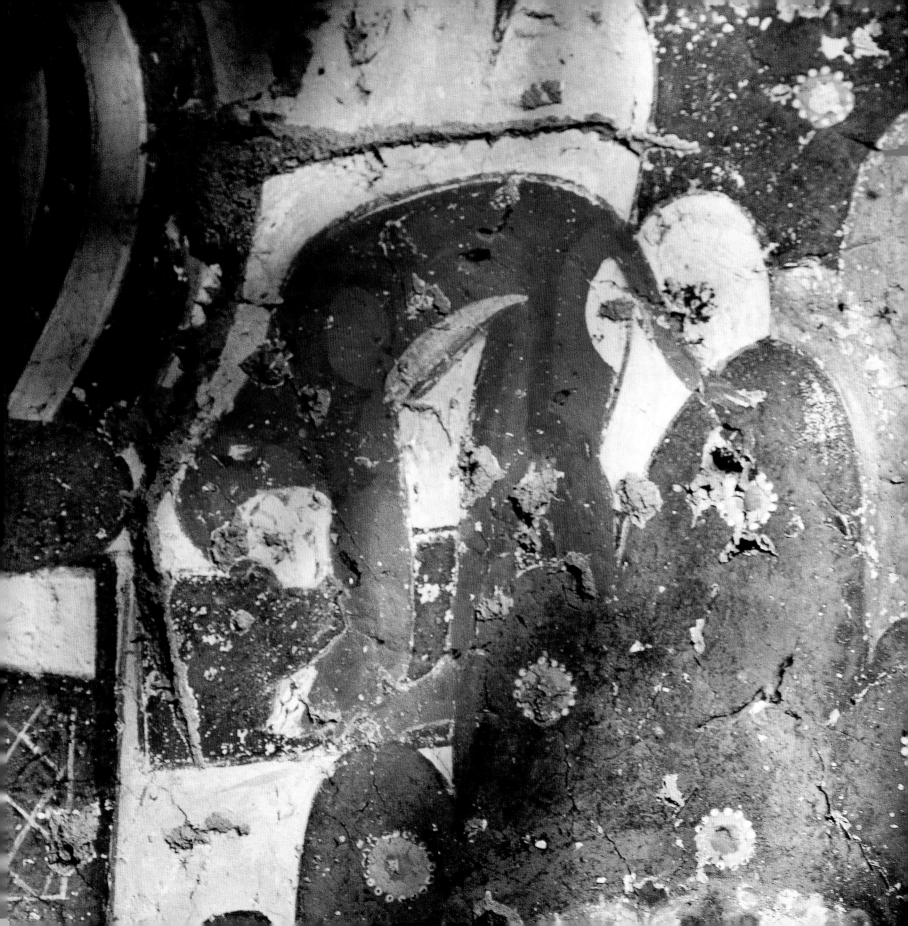

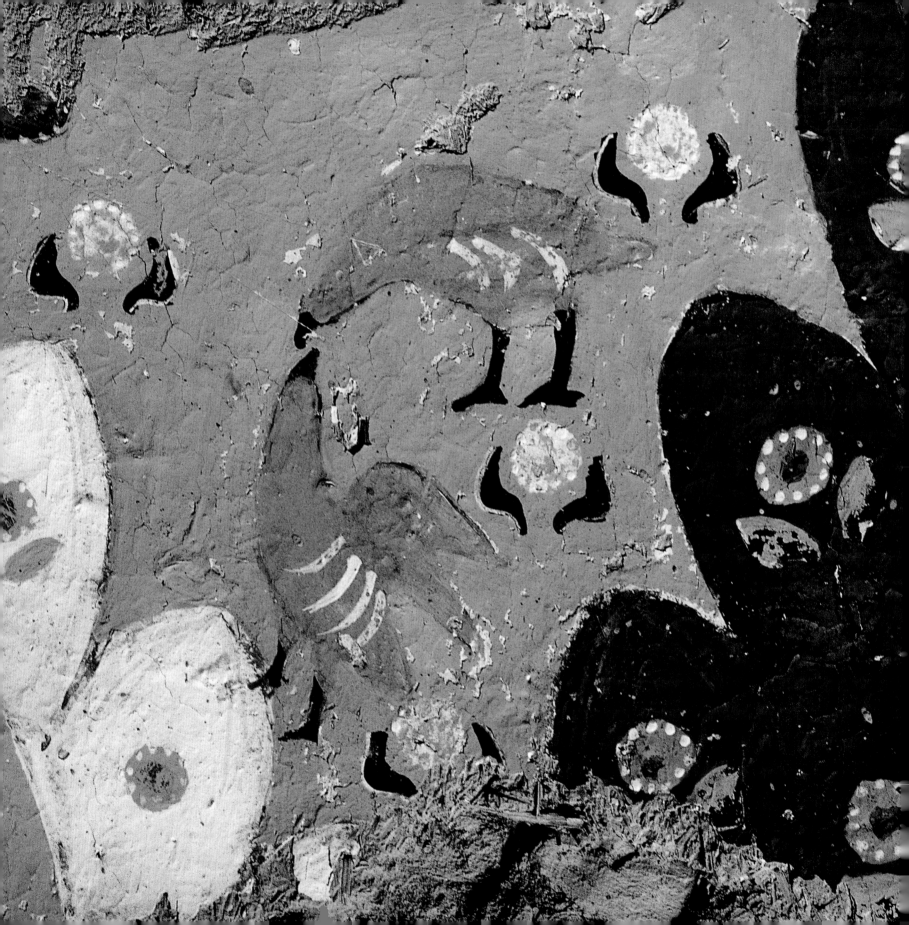

An underground aviary

Birds are ubiquitous in the cave scenes at Kizil, particularly partridges. These are mentioned by the French archaeologist Paul Pelliott in his expedition diary. He hunted them to supplement his party's food rations.

[Maya Cave III]

Wild geese in orbit

As migratory birds, wild geese symbolize the transmigration of souls. They are frequently shown orbiting the sun or moon, as on the overhead frieze in the Musicians' Cave (this frieze represents a bridge between the worlds of heaven and earth). Sometimes geese are seen drawing the chariot of an important disciple.

[Musicians' Cave]

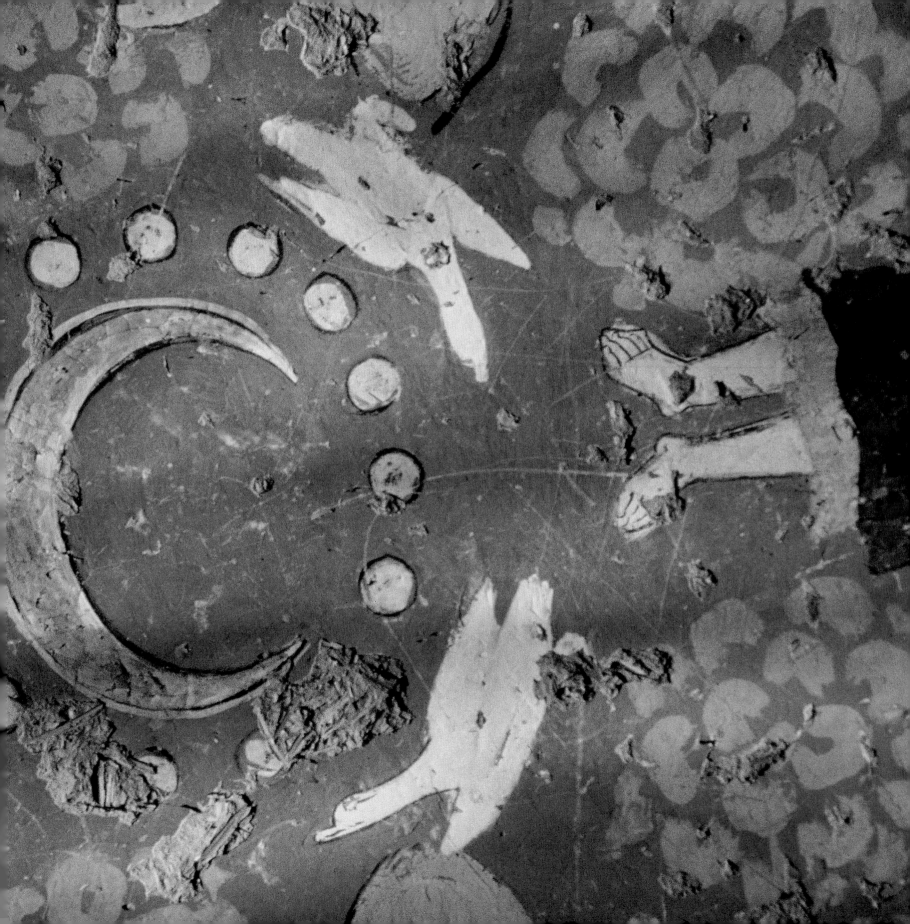

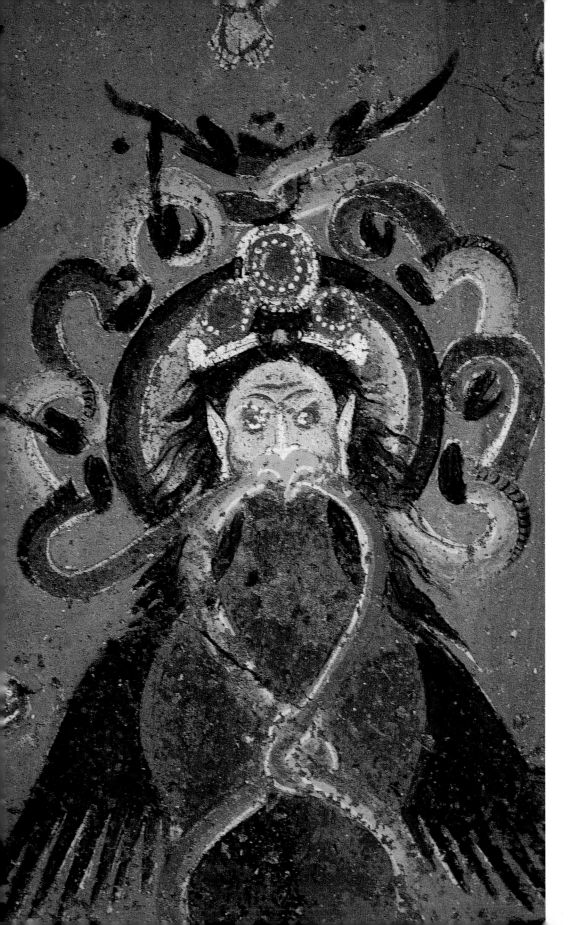

The serpent-slayer

This fabulous bird with human body (overhead frieze, Cave 171) is Garuda, the vehicle of the Hindu god Vishnu. Garuda, a sworn enemy of the *nagas* (stylized cobras), kills snakes.

[Cave 171]

A philanthropist in peacock feathers

The peacock was very common in Kucha. Although a native of India, it acclimatized well and spread throughout Central Asia. A number of specimens were sent to the Chinese court. The bird also occurs frequently in Buddhist texts, where its role is philanthropic. The Chinese monk Xuanzang mentions an incarnation of the Buddha as a peacock that could make healing water spring from a rock.

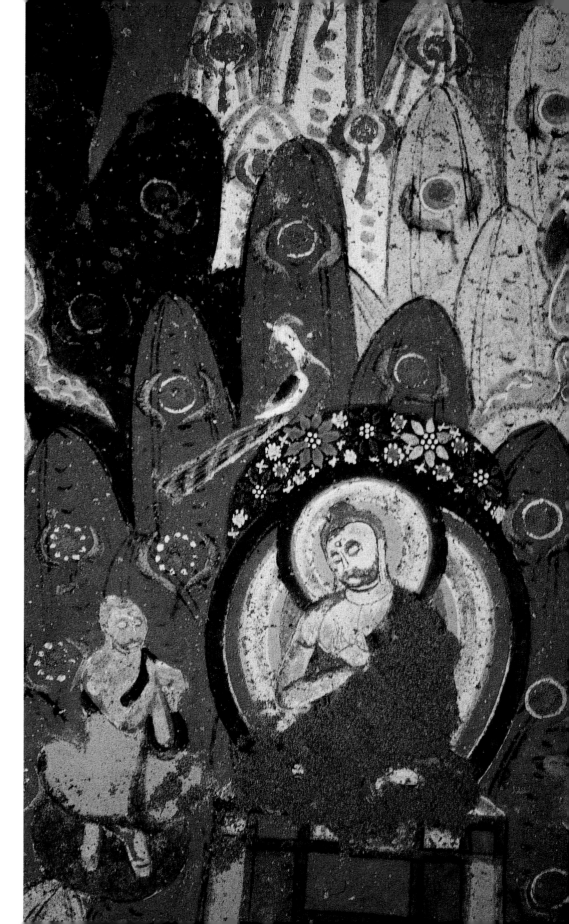

[Cave 171]

Bird of prey

The eagle features in several narratives, including the tale of the lion who protected the young monkey (see p. 95). Xinjiang forms part of the Central Asian habitat of large birds of prey such as the eagle or osprey. In Kazakhstan, which borders ancient Chinese Turkestan, the skeleton of an eagle was discovered in the tomb of a Neolithic hunter, while in the autumn of 1999 an archaeo-zoologist from the Paris Natural History Museum noticed an eagle flying over an excavation site.

[Cave 14]

▶ *[Cave with the Bodhisattva Vault]*

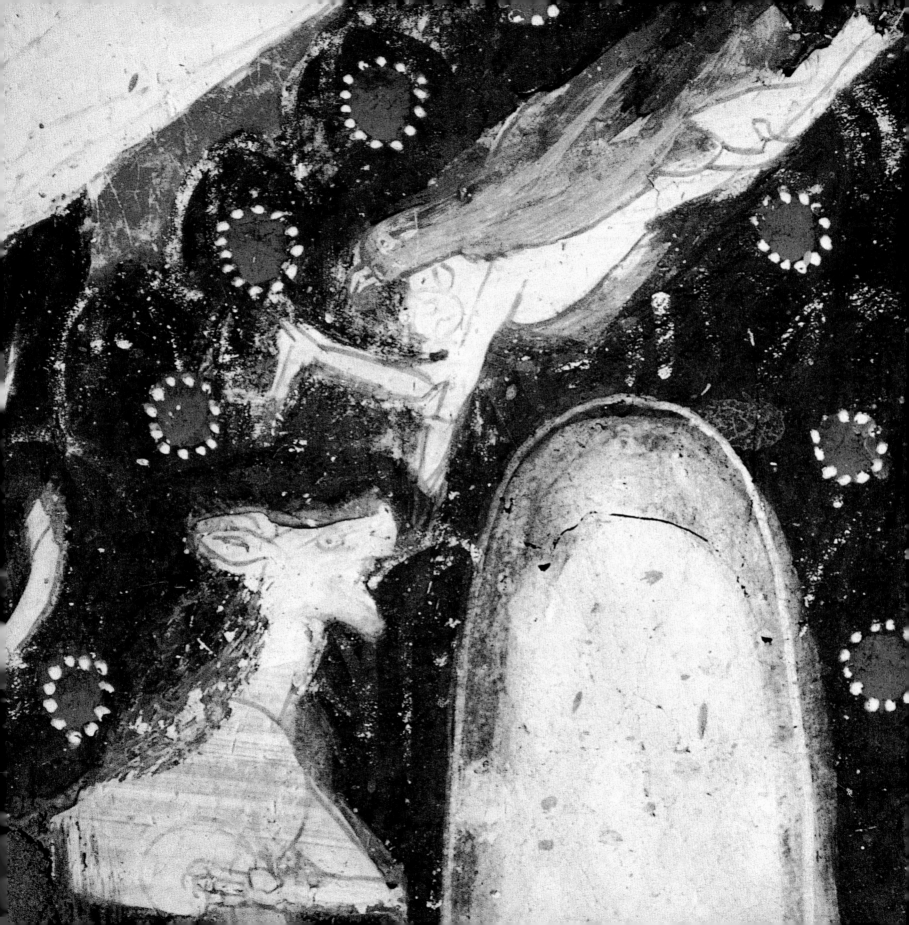

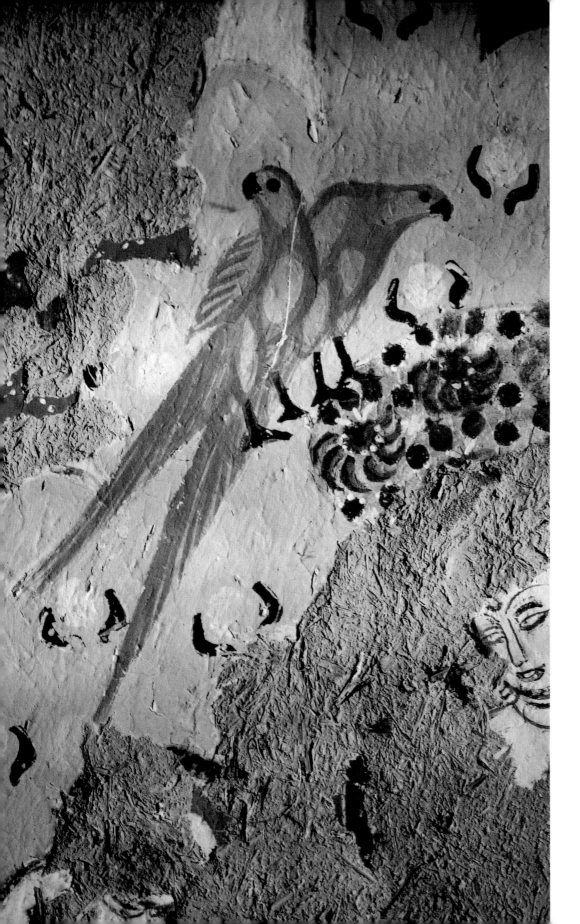

When parakeets could (really) talk

Parakeets are commonplace in Buddhist rock paintings. According to legend they had the power of speech, and they were known as the 'holy birds of the western regions'. In order to paint them, artist-monks must have taken as their model the variety *Psittacula derbyana*, native to Sichuan or Tibet and found in the Lung mountains, along the frontier with Gansu. These birds are green with mauve breasts; they were sought after as items of tribute for the Imperial Court.

[Maya Cave III]

The Buddhist pigeon

The pigeon is a symbol of sacrifice. In the famous *Cibi jataka* a pigeon pursued by a sparrow-hawk takes refuge in the lap of the king of the Cibi, who takes her under his protection. The bird of prey protests its hunger. 'What shall we eat, my family and I, so we don't starve?' The king places the pigeon on a pair of scales and gives the sparrow-hawk the equivalent weight of his own flesh.

[Maya Cave III]

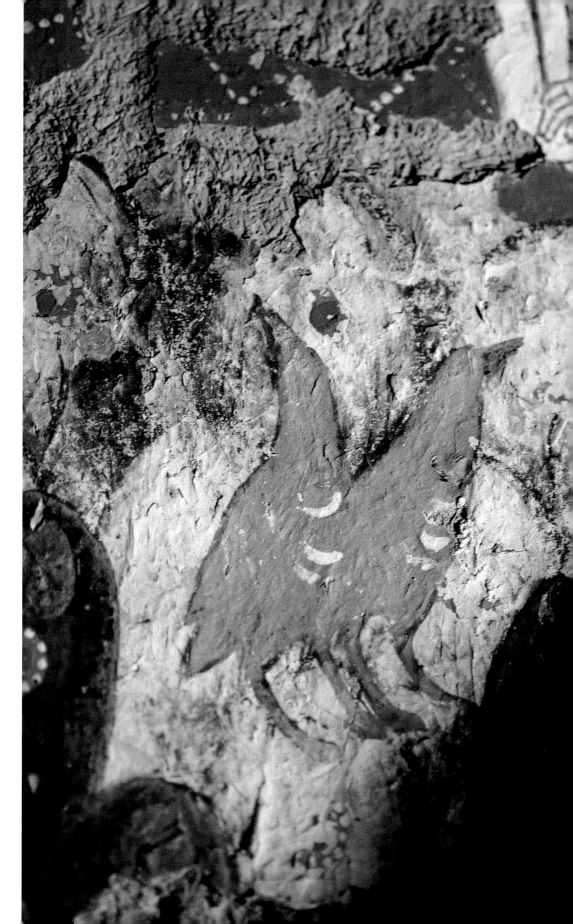

Silk worm or sea worm?

Sea creatures feature rarely in the cave paintings, with one very special exception: on the false joist of the Musicians' Cave various shells, curious fish and bizarre, worm-like creatures with feline faces drift among gemstones.

The worm of a lapis-lazuli colour that appears on the supports of the barrel vault is most probably a silk worm. According to legend, the Princess of Khotan (on the Southern Silk Road) brought the precious cocoons to Kucha. In the cave paintings, everything connected with silk symbolizes the upper world, while the sea, the lower world, is represented by shells.

[Musicians' Cave]

160

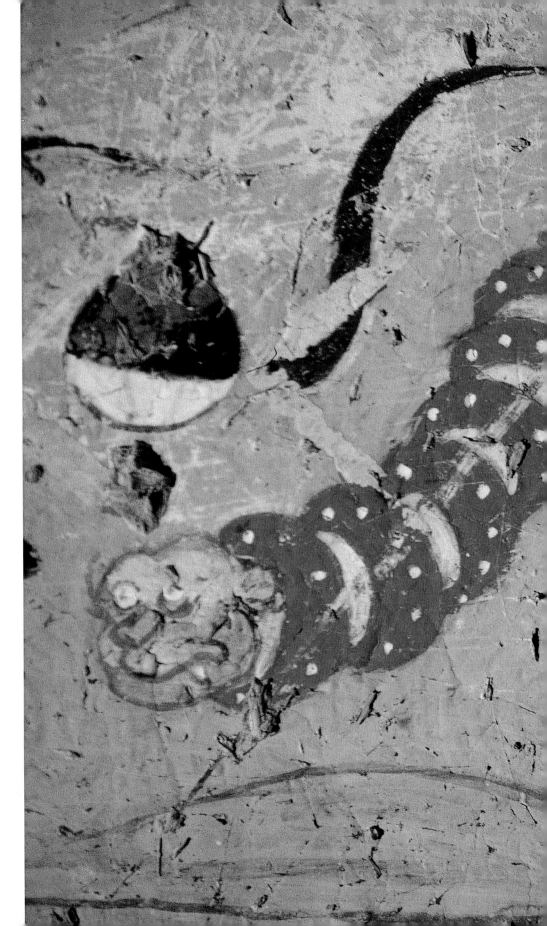

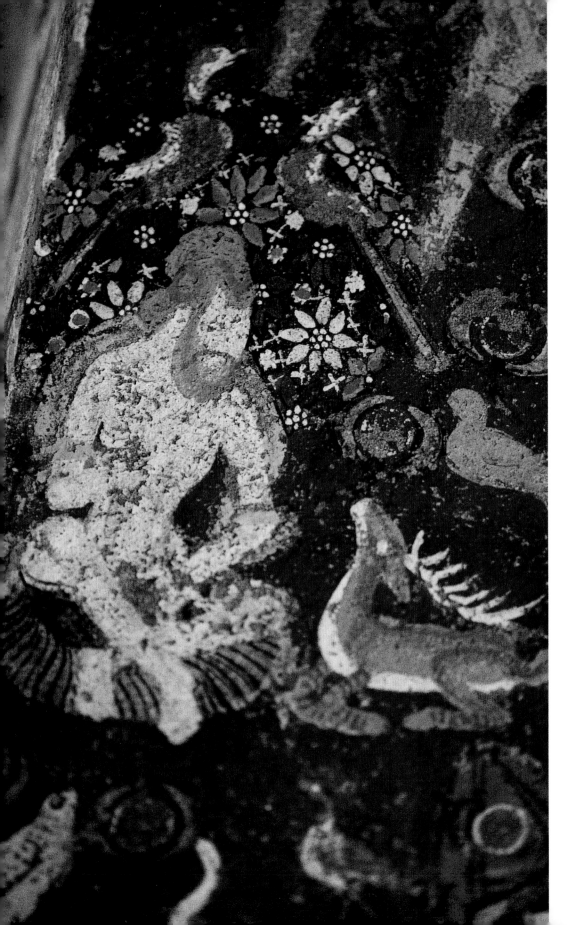

A congregation of animals

In preaching scenes the audience often consists of animals, listening devotedly and attentively, as here. An ascetic, sitting on a clump of grass, explains the source of suffering to a gathering of parakeets, ducks, fallow deer, snakes and pigeons. Following the example of the parakeets perched in a tree above his head, the animals hang onto his every word.

[Cave 171]